The Art of Colouring

By Jesse Samuel Wood
(Samuel J Art)

Copyright © 2016 Jesse Samuel Wood
(Samuel J Art)
All rights reserved.
ISBN-10: 1535587032
ISBN-13: 978-1535587037

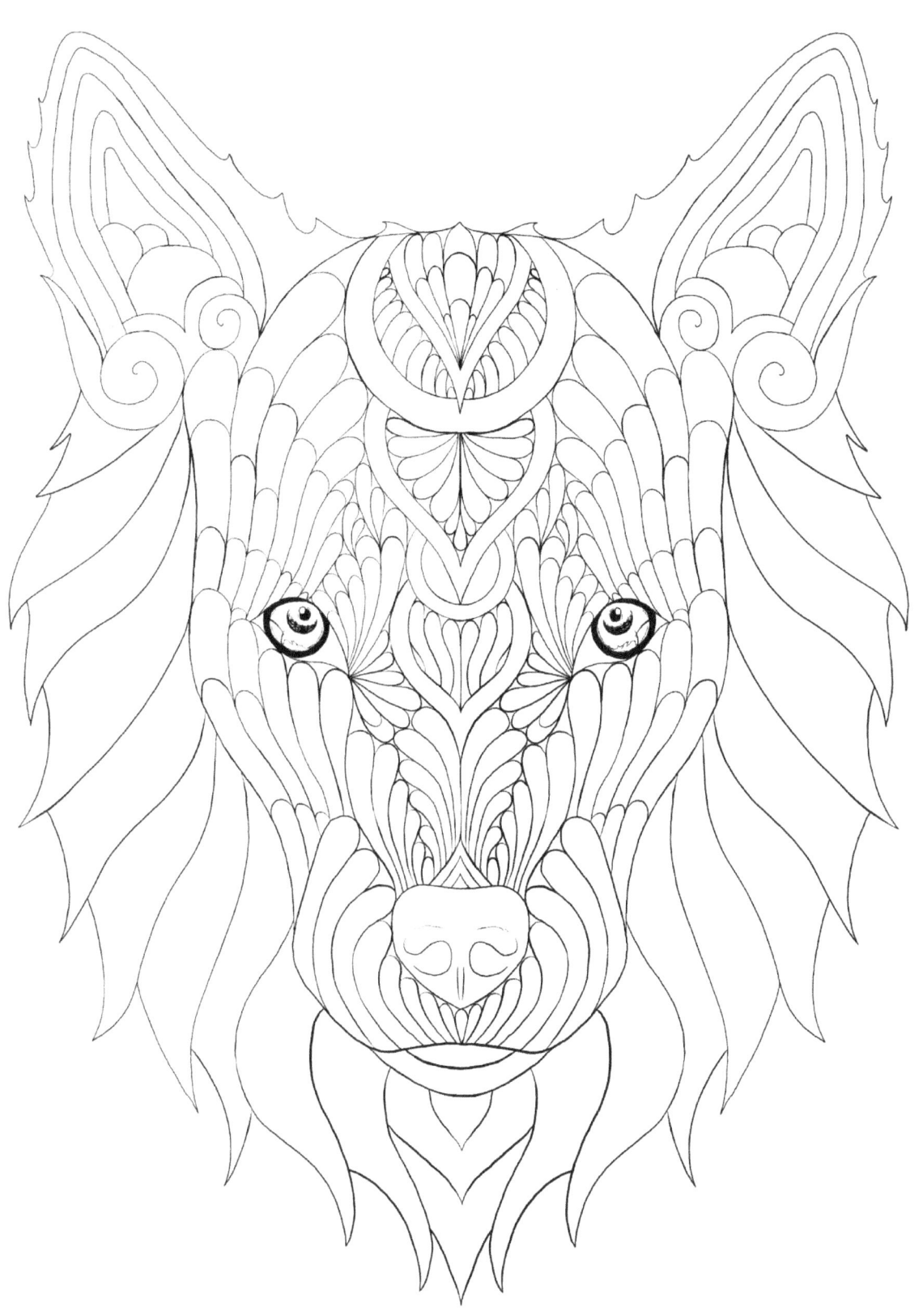

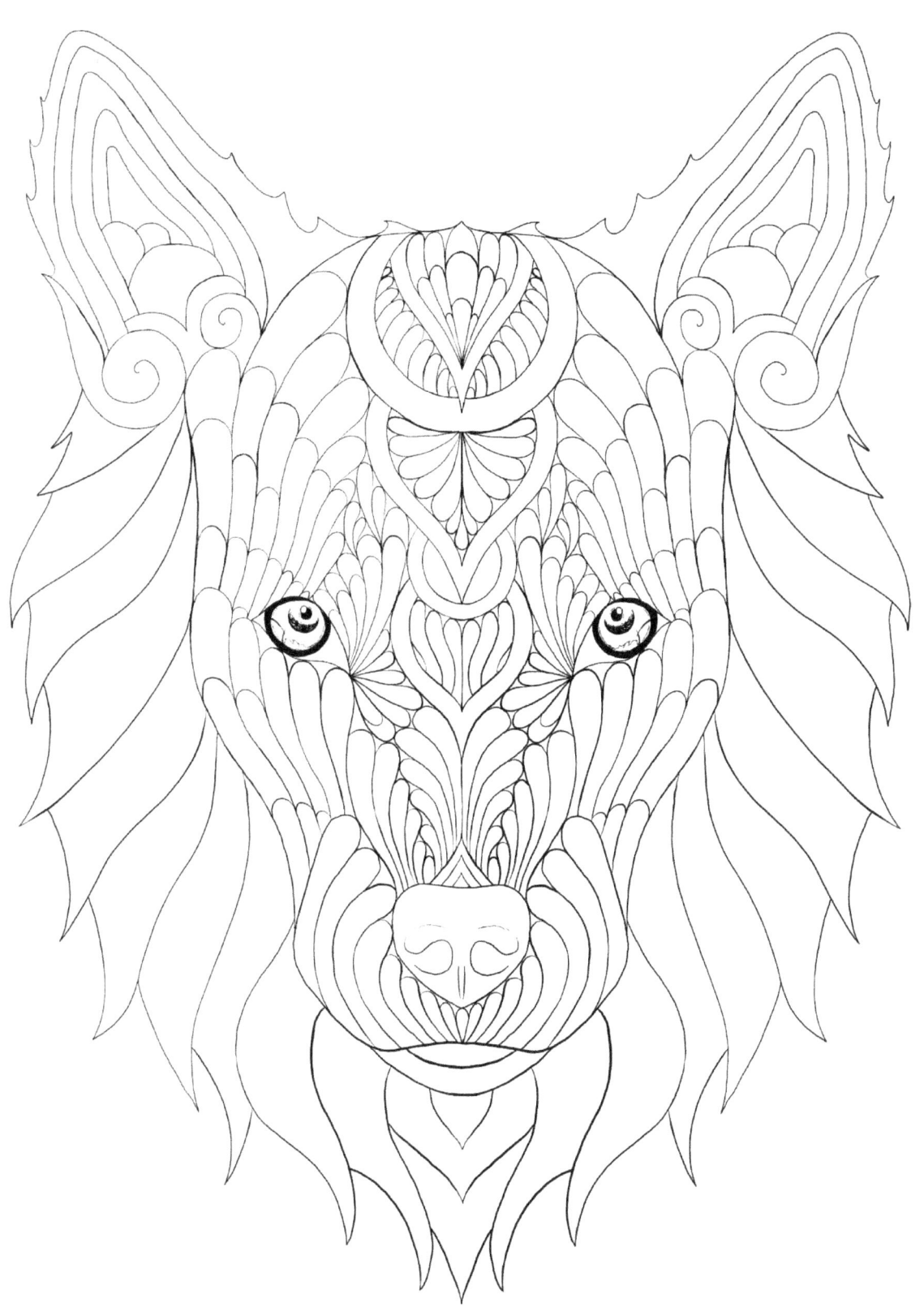

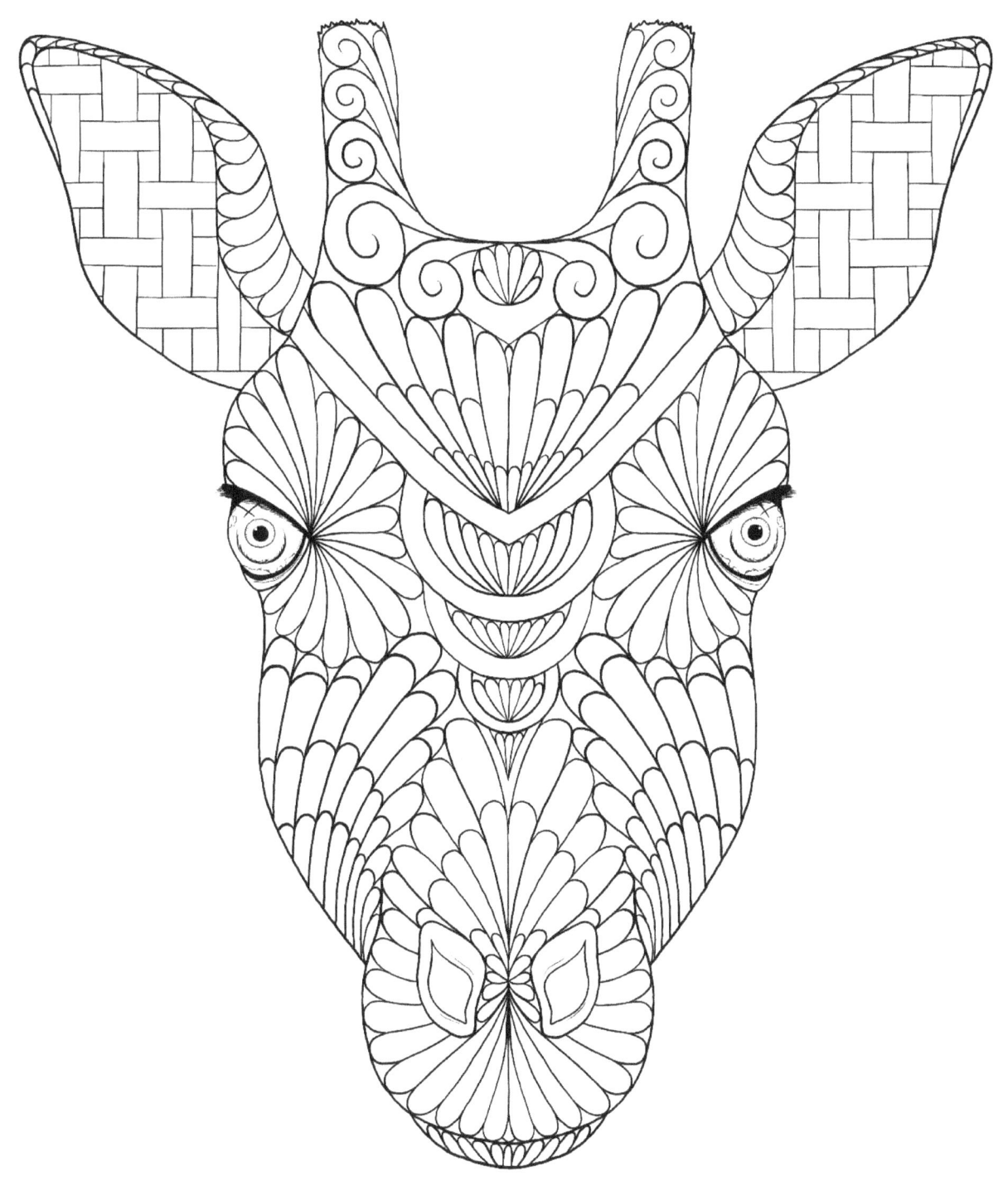

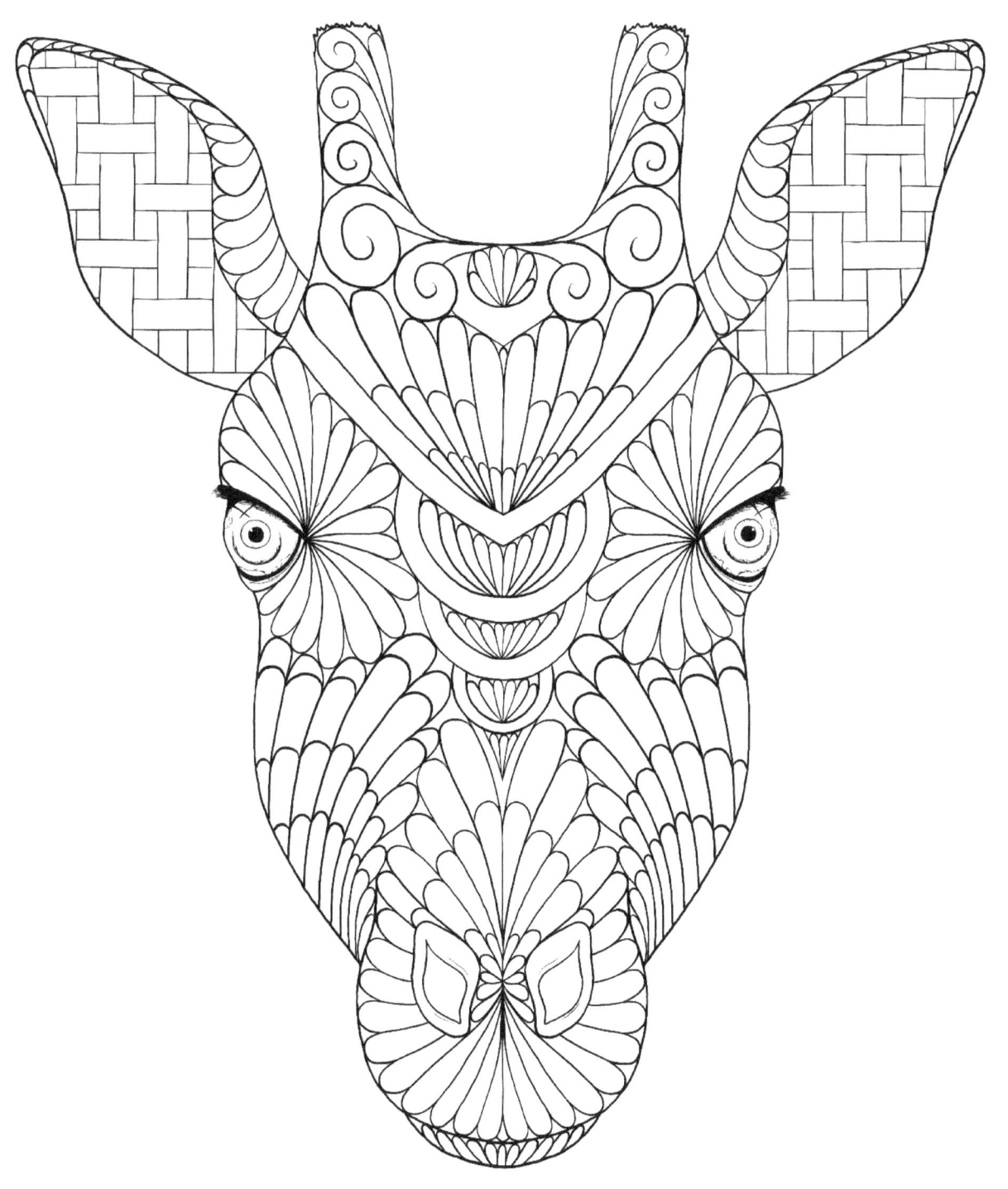

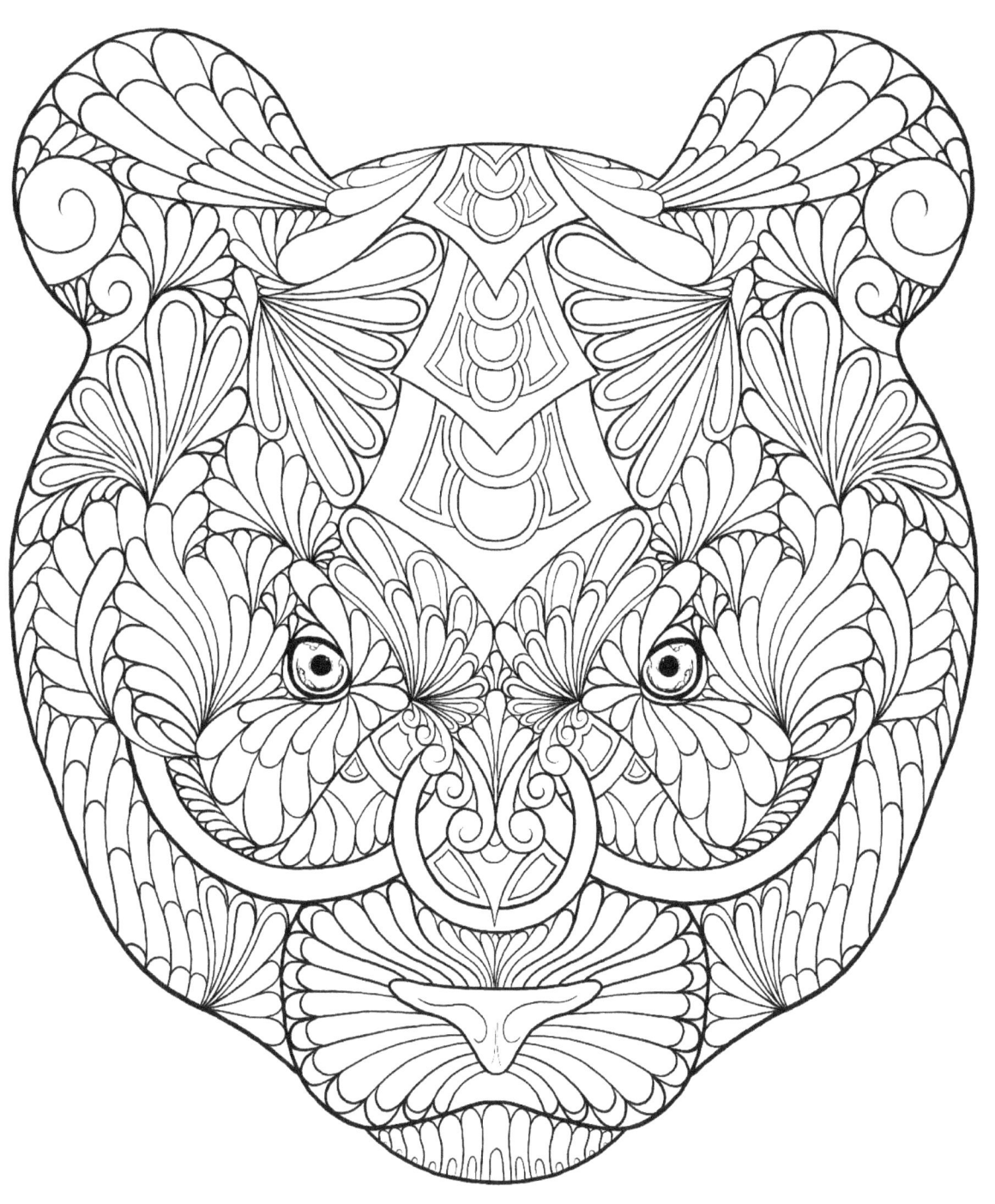

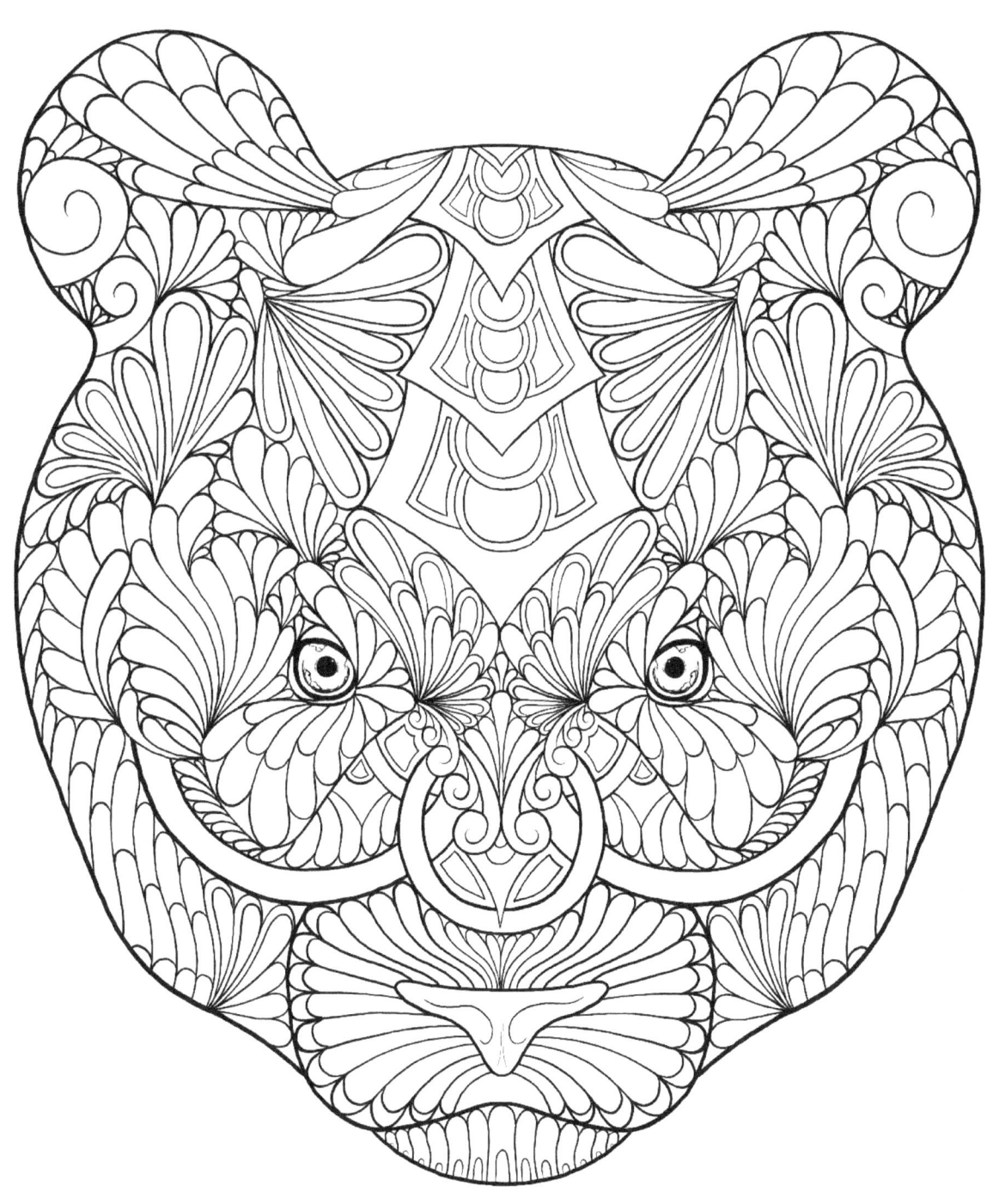

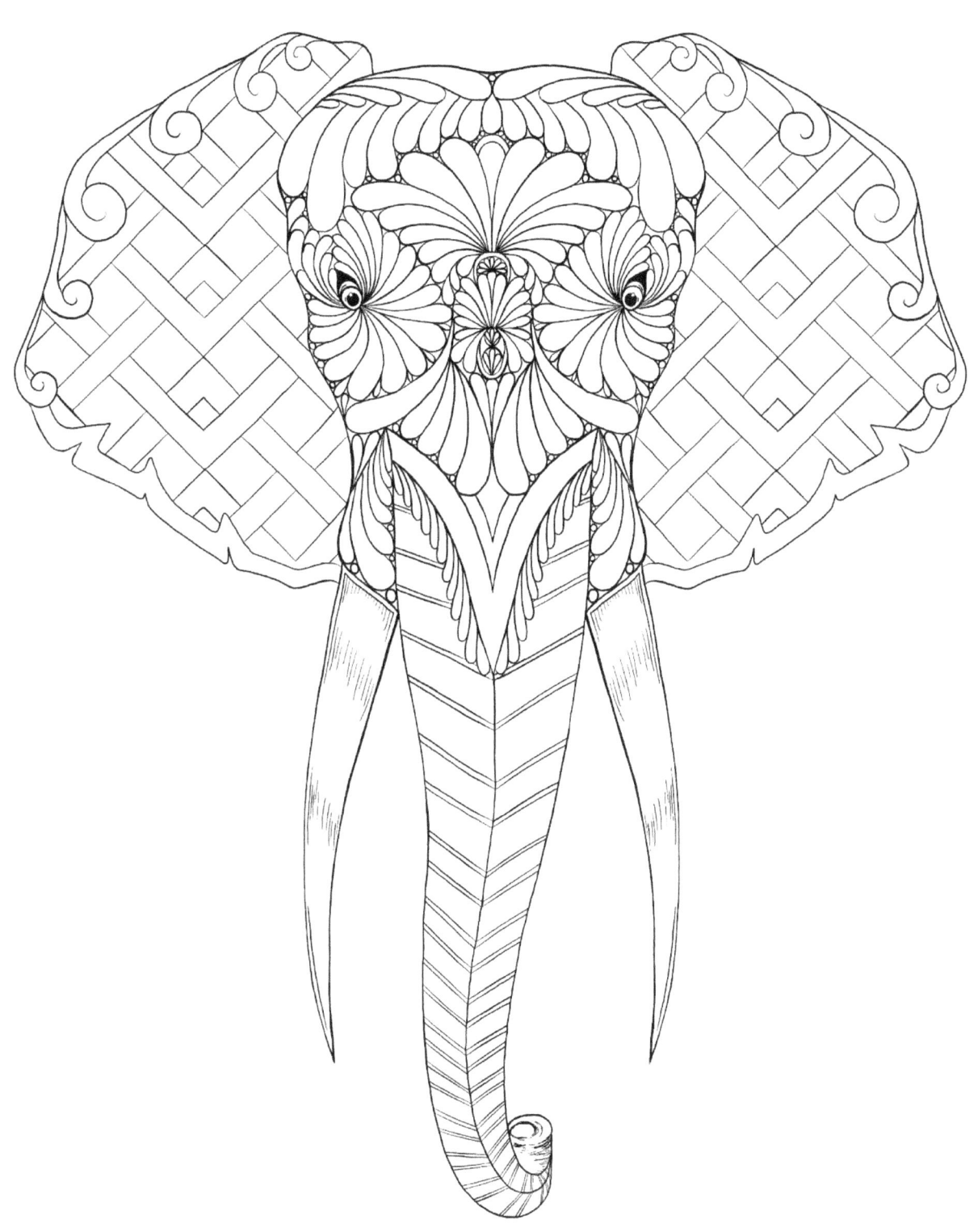

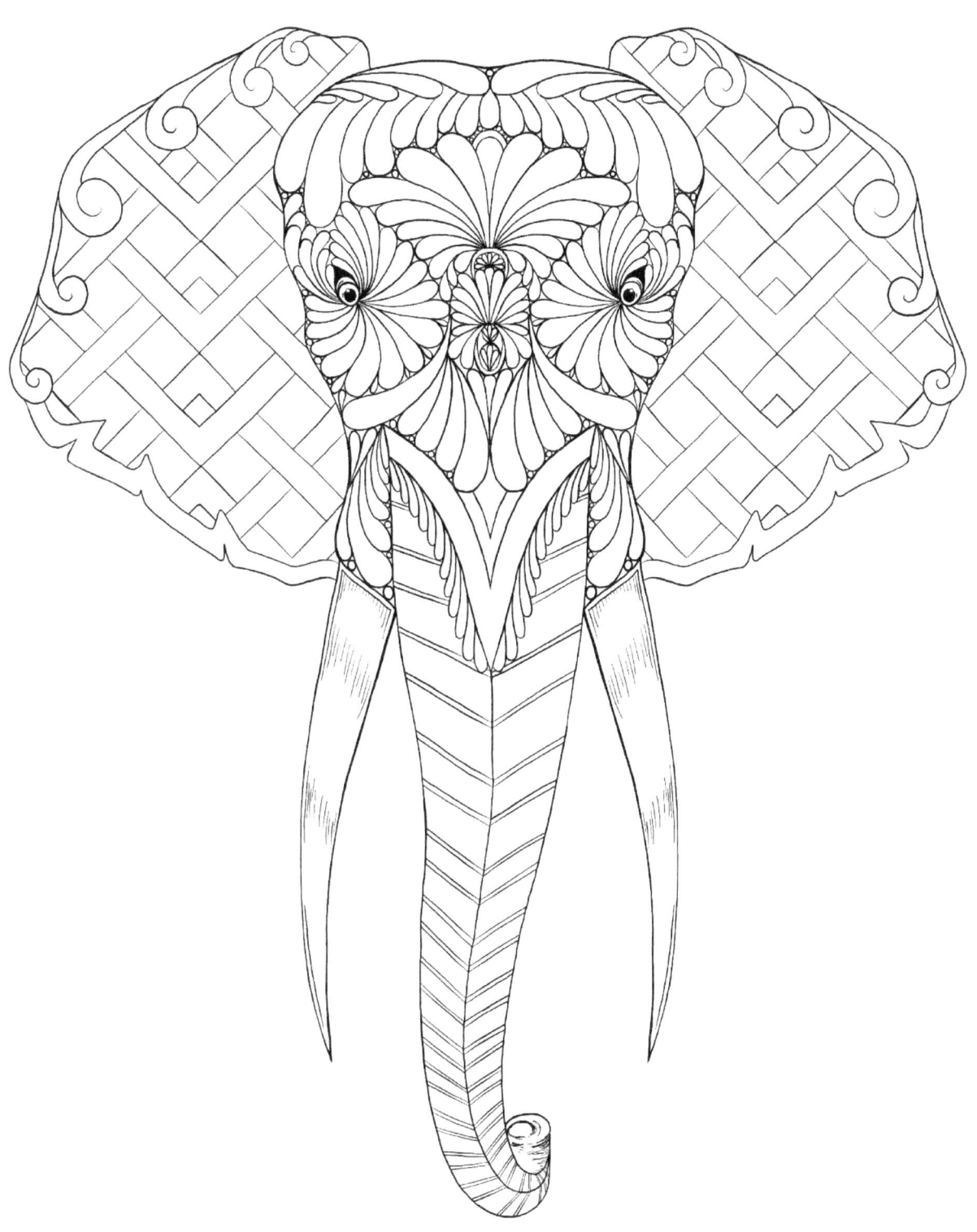

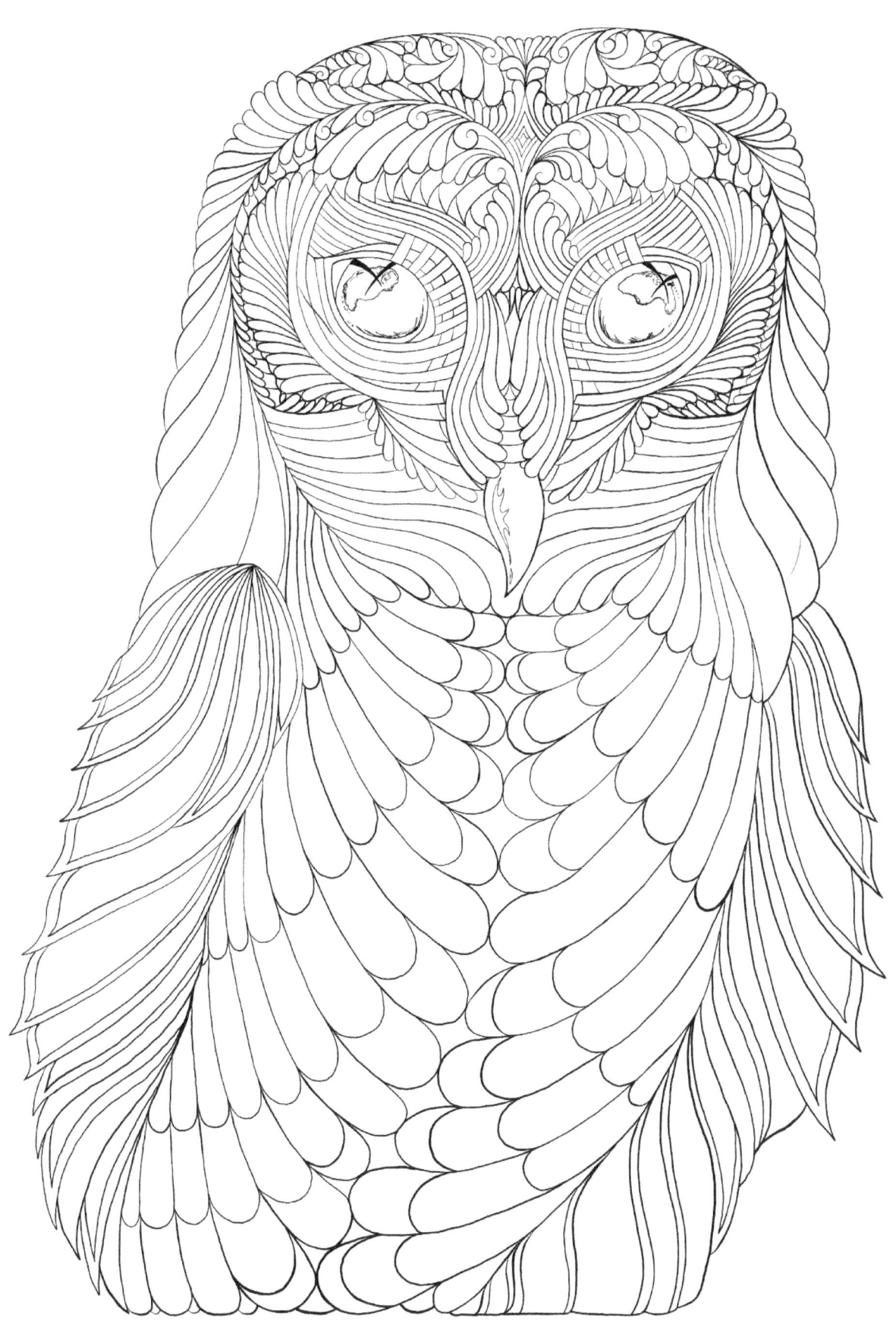

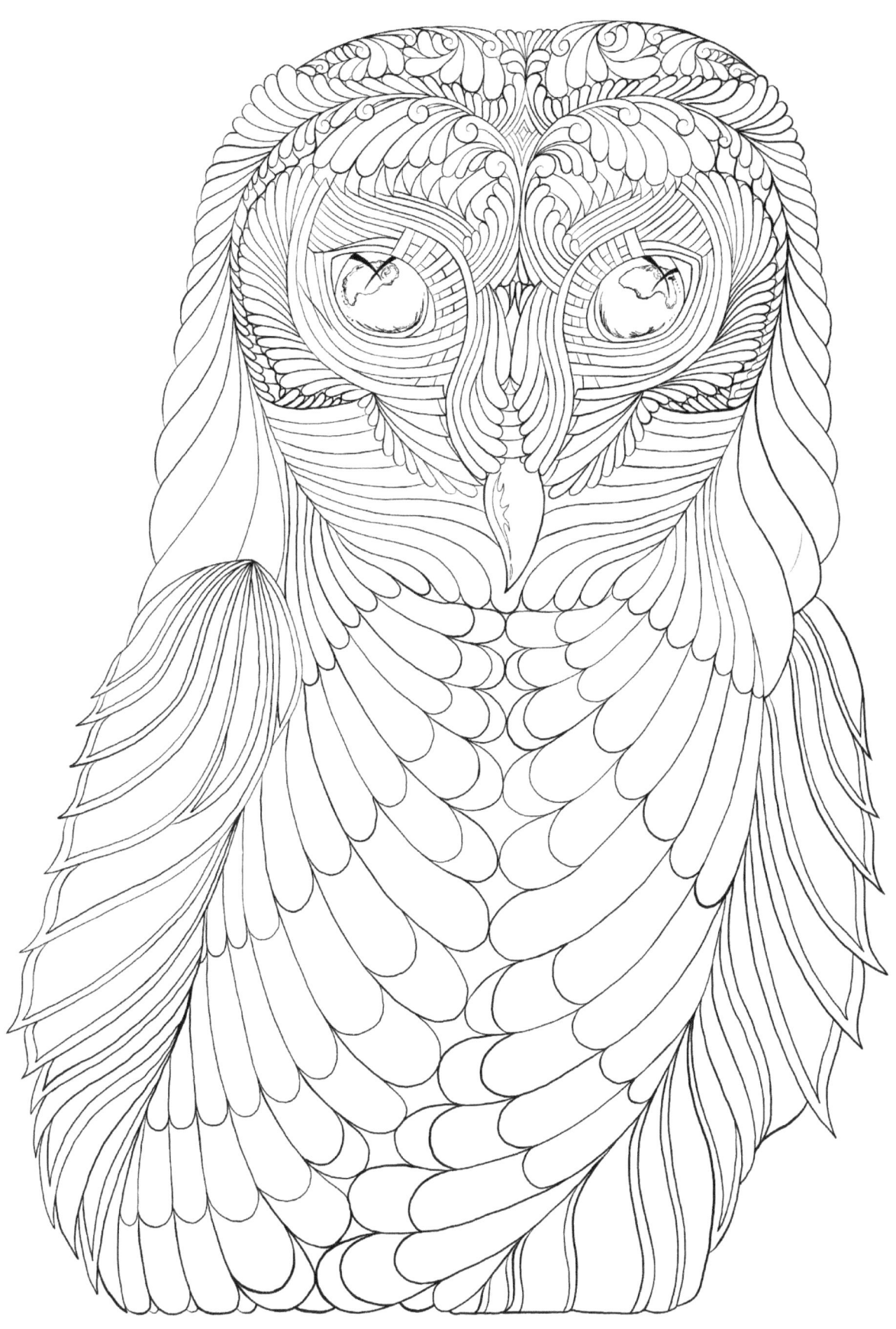

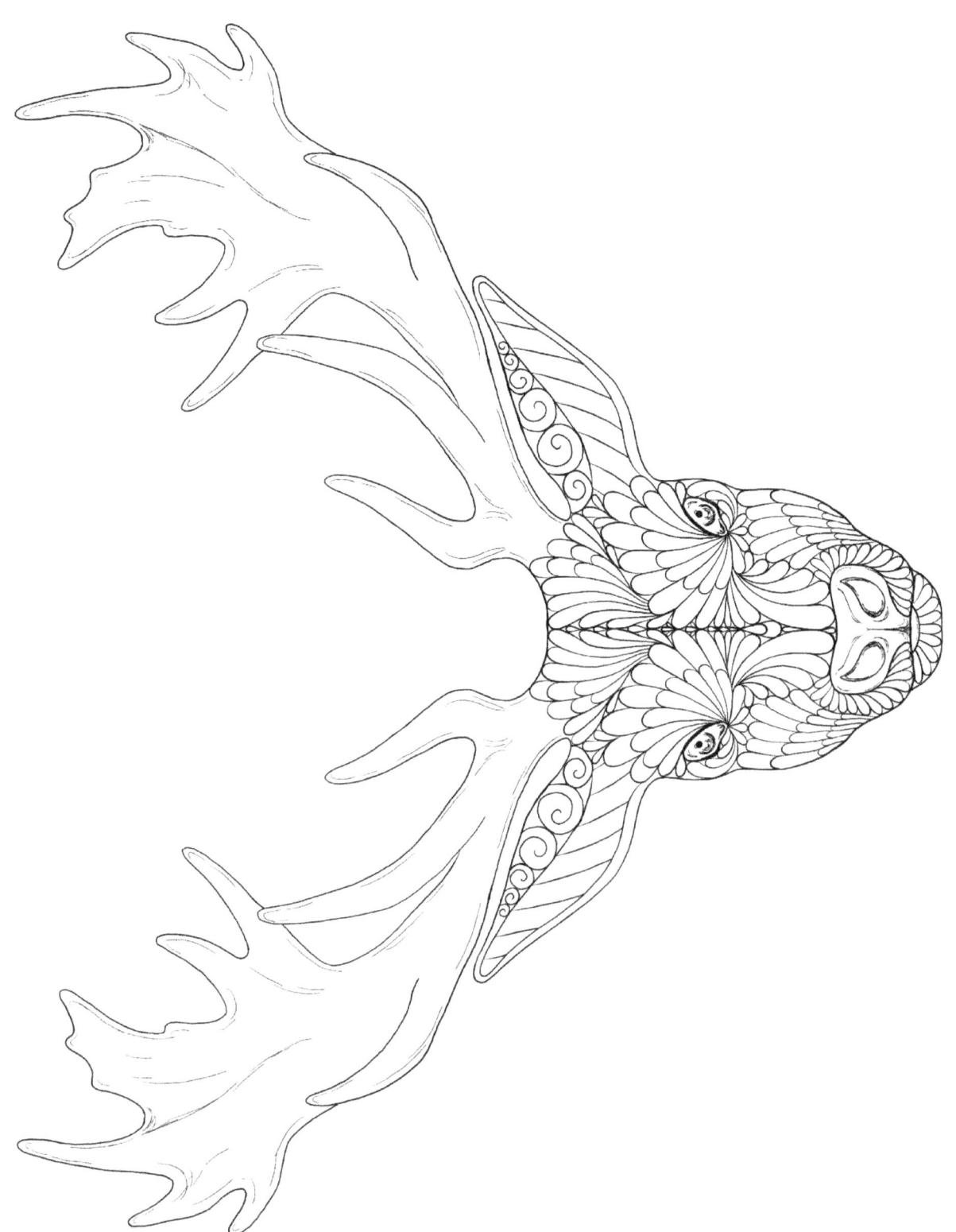

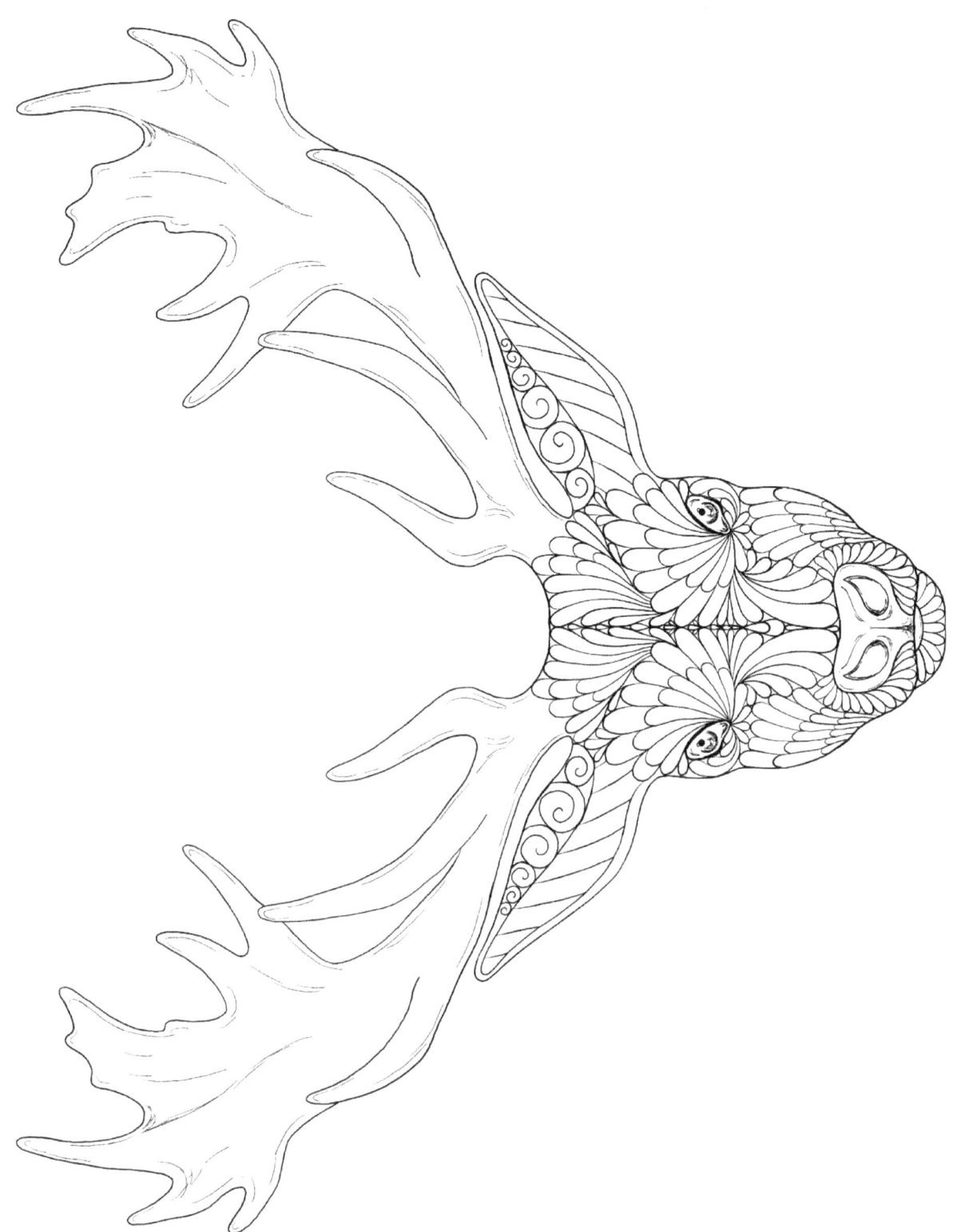

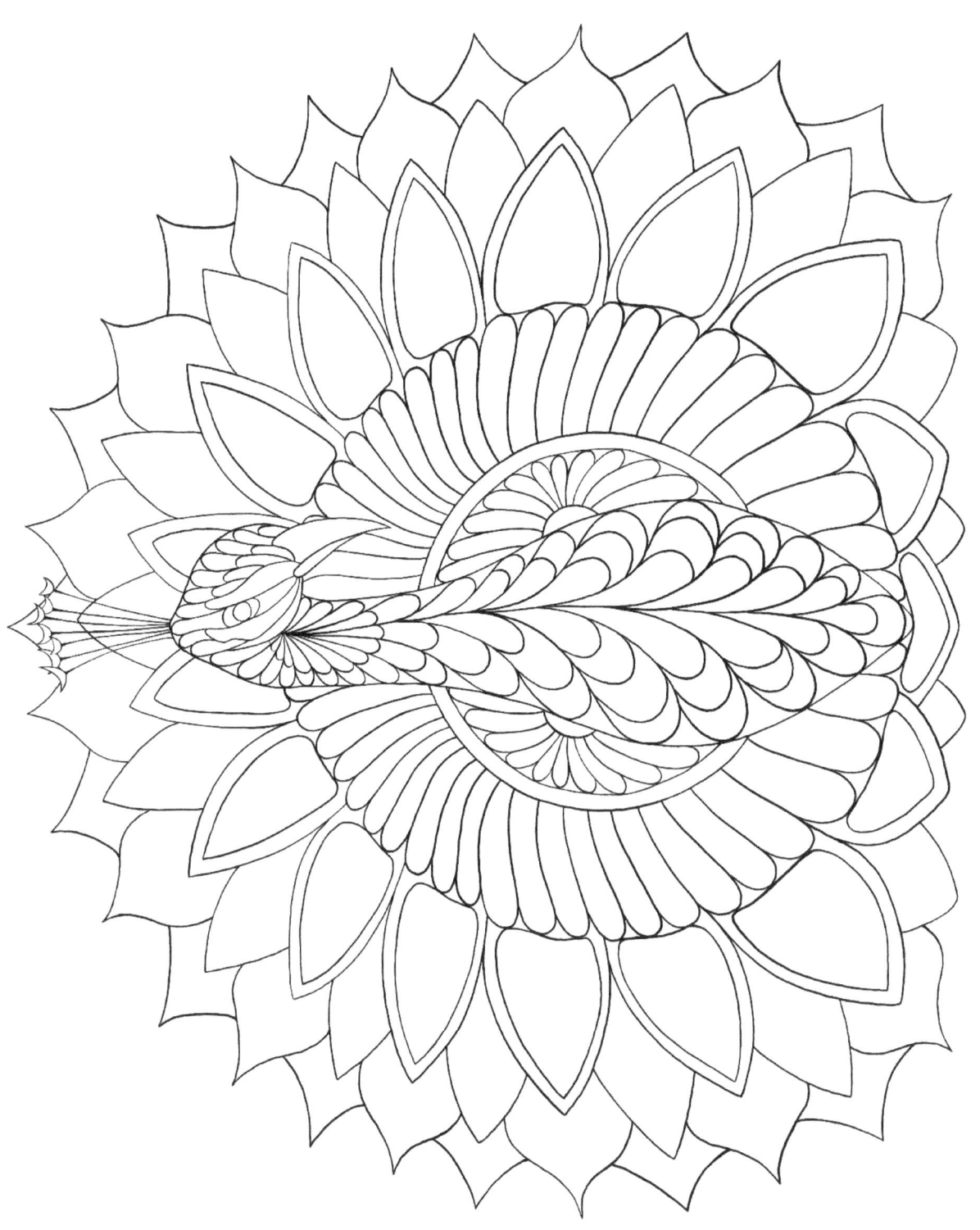

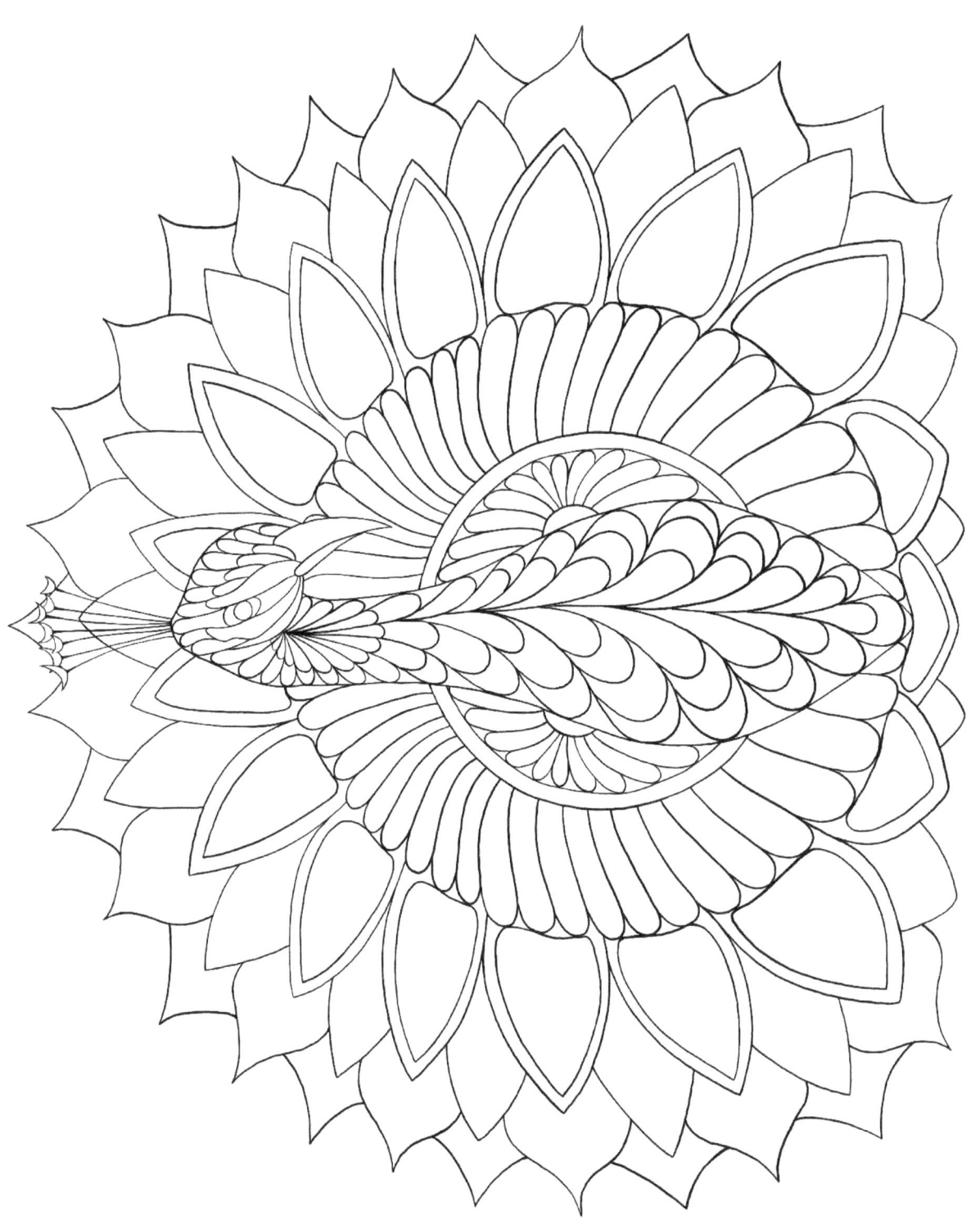

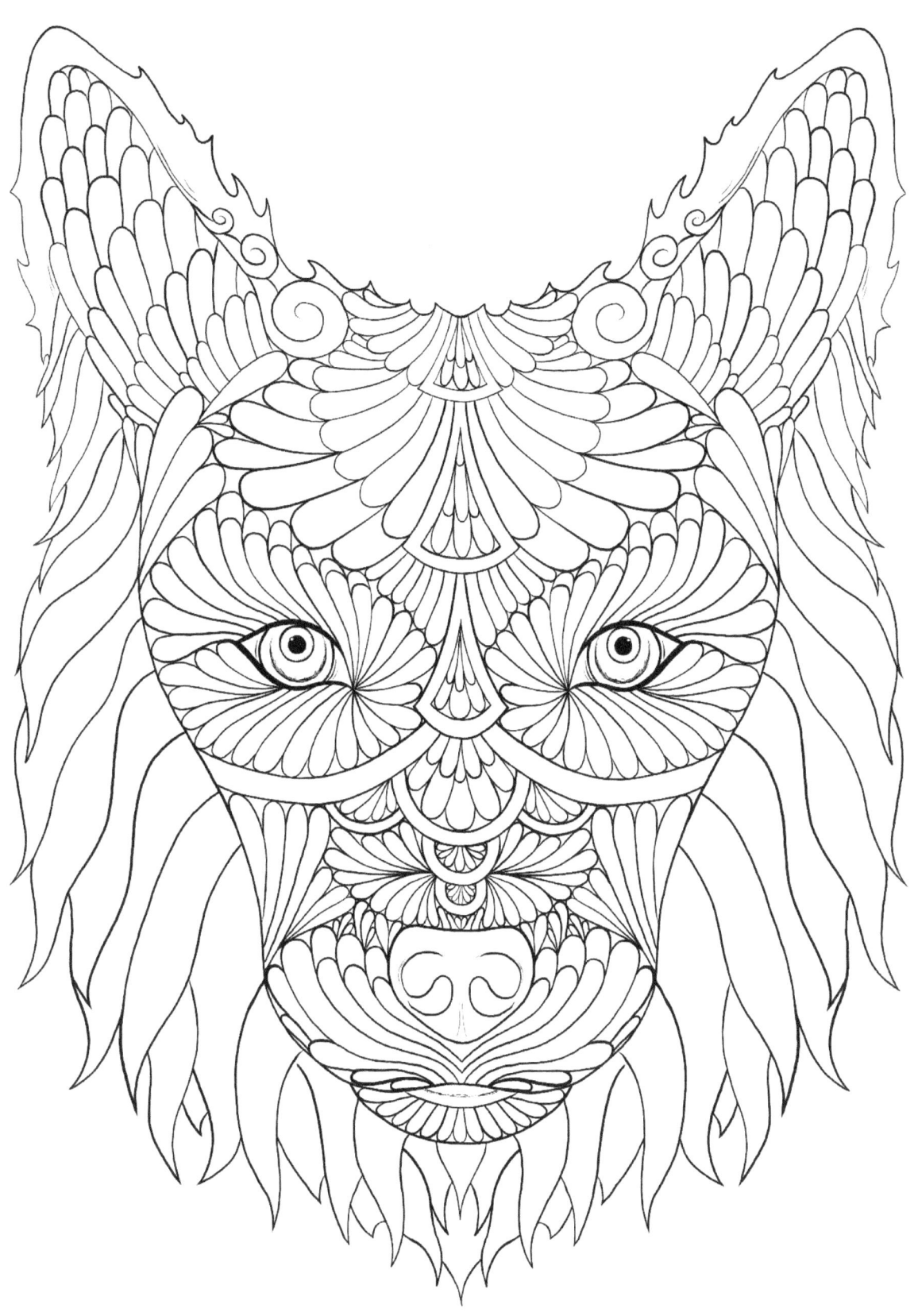

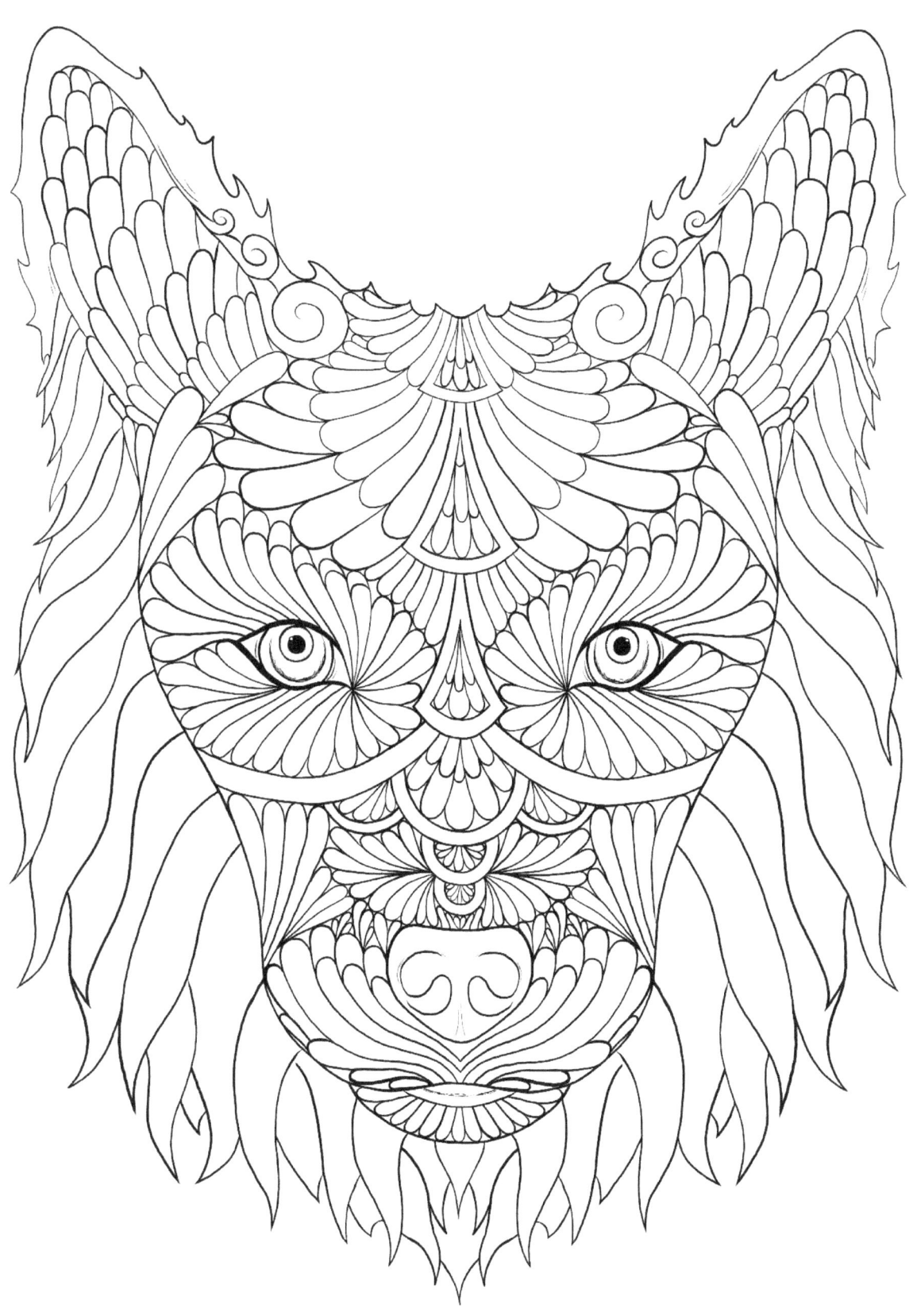

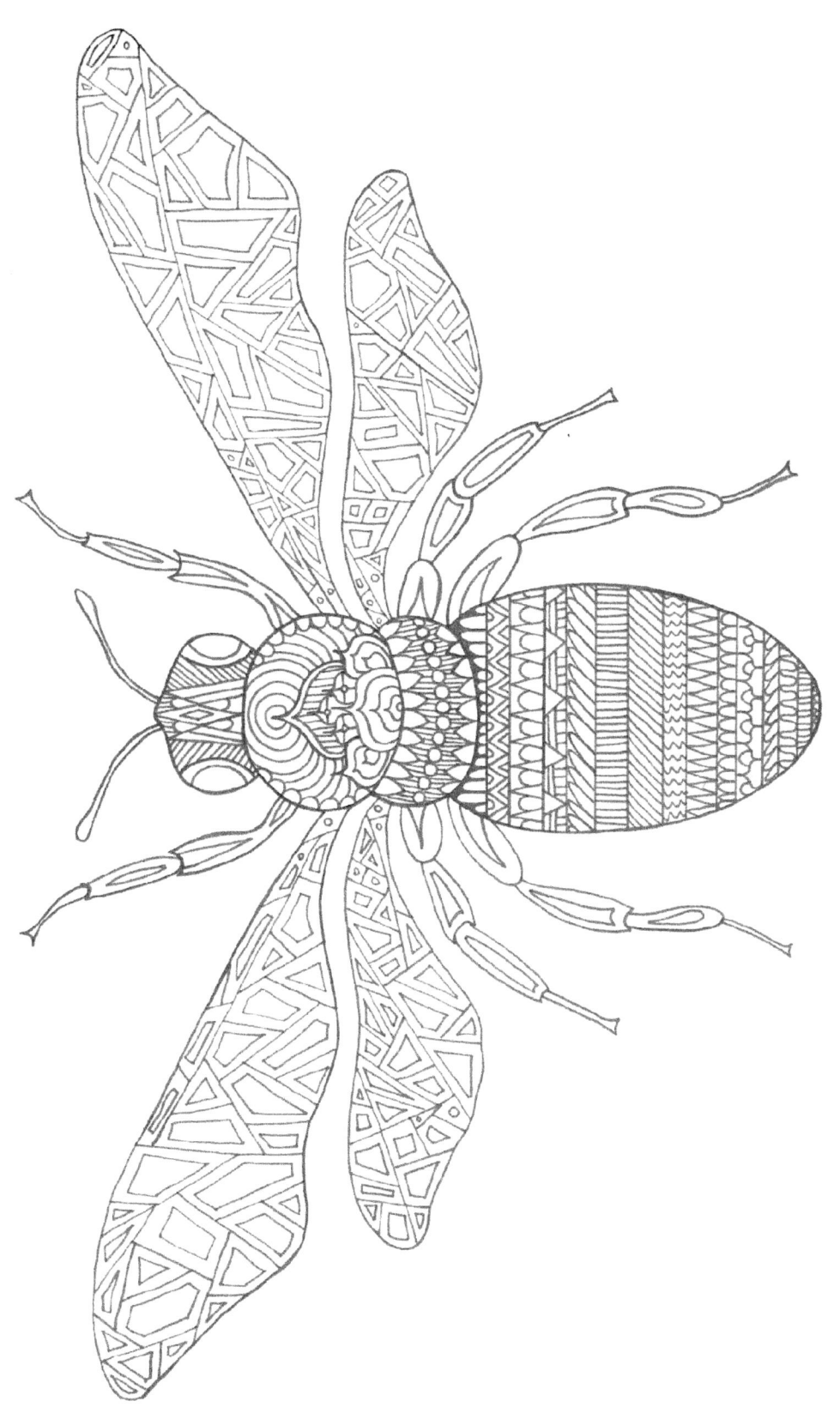

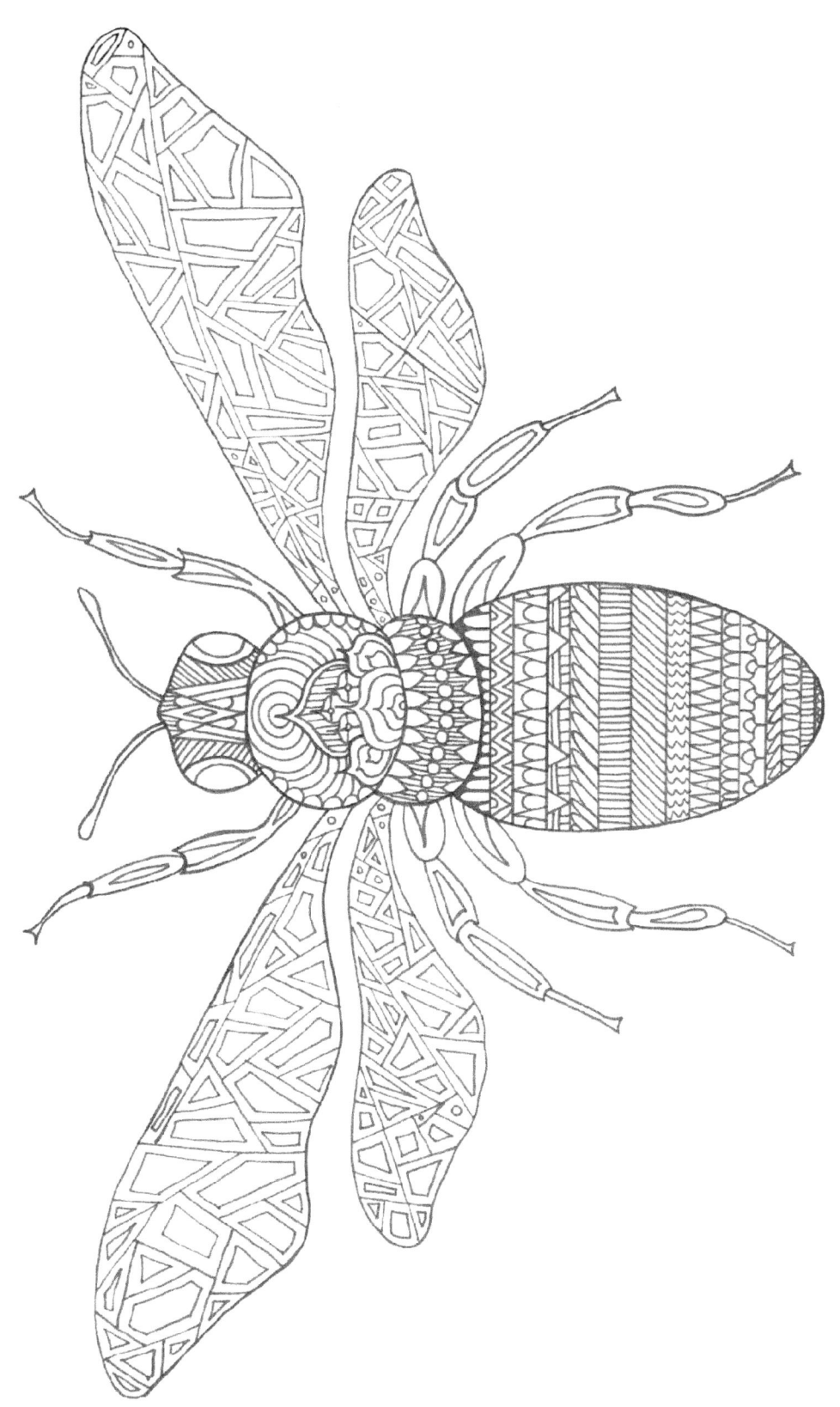

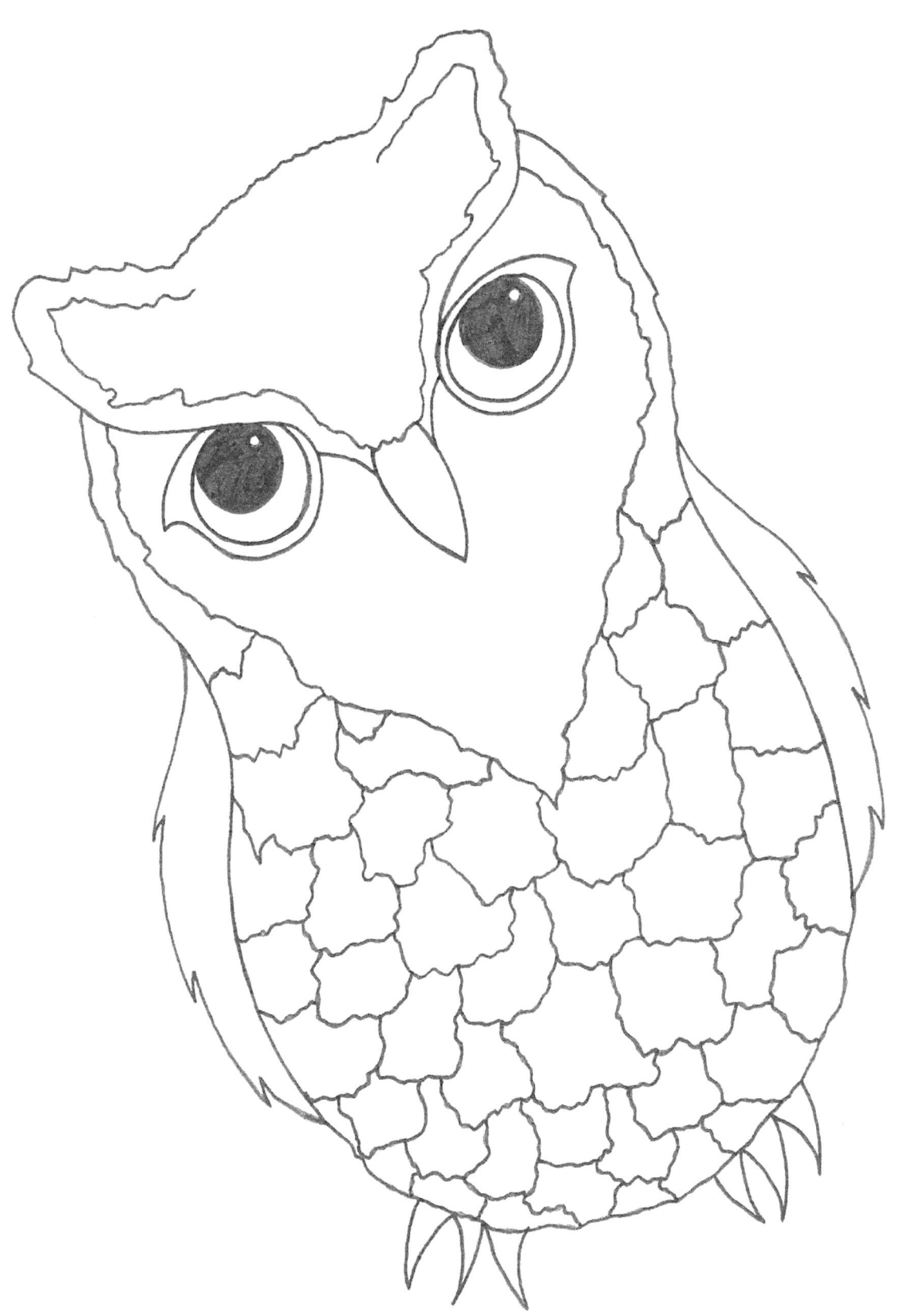

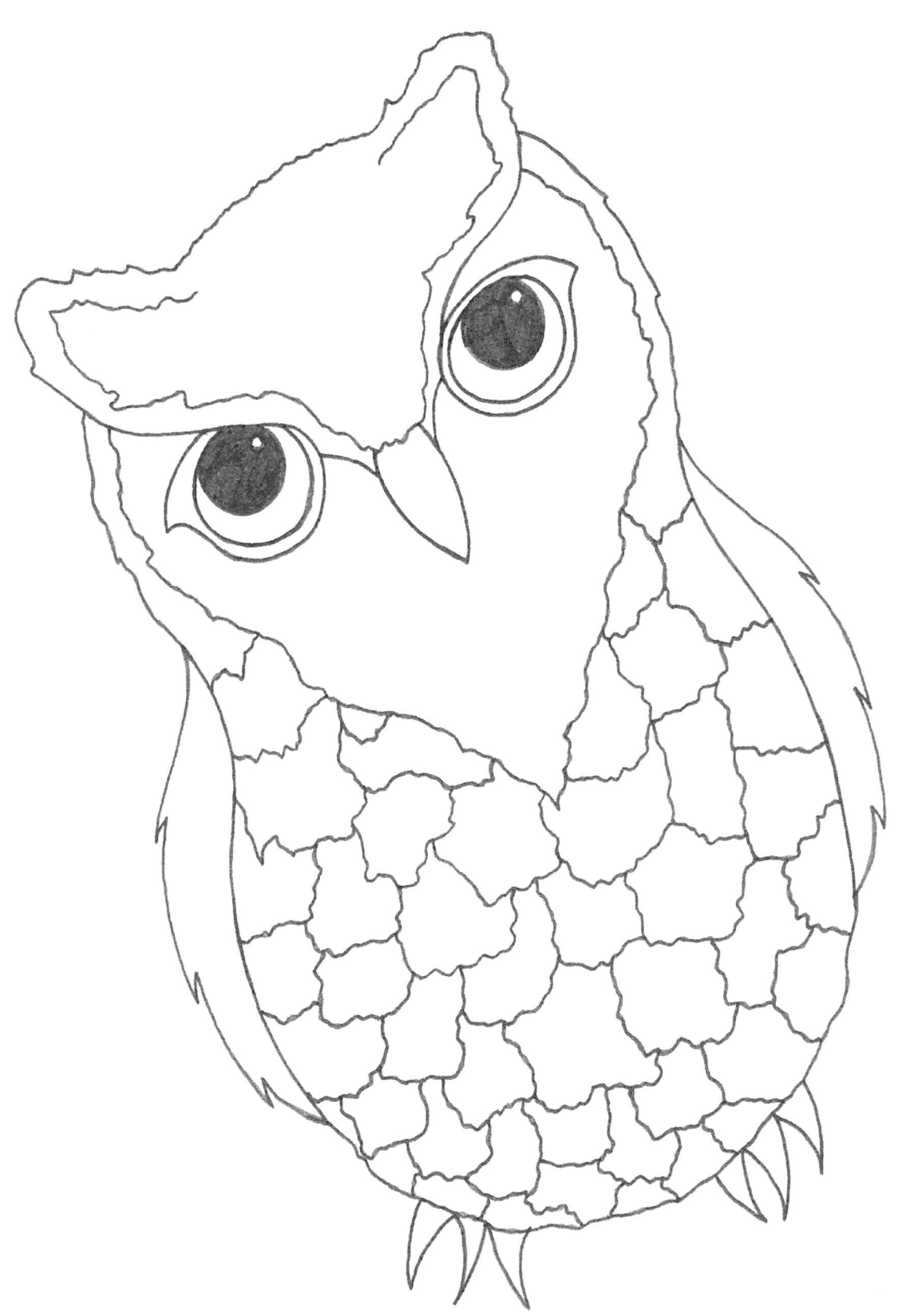

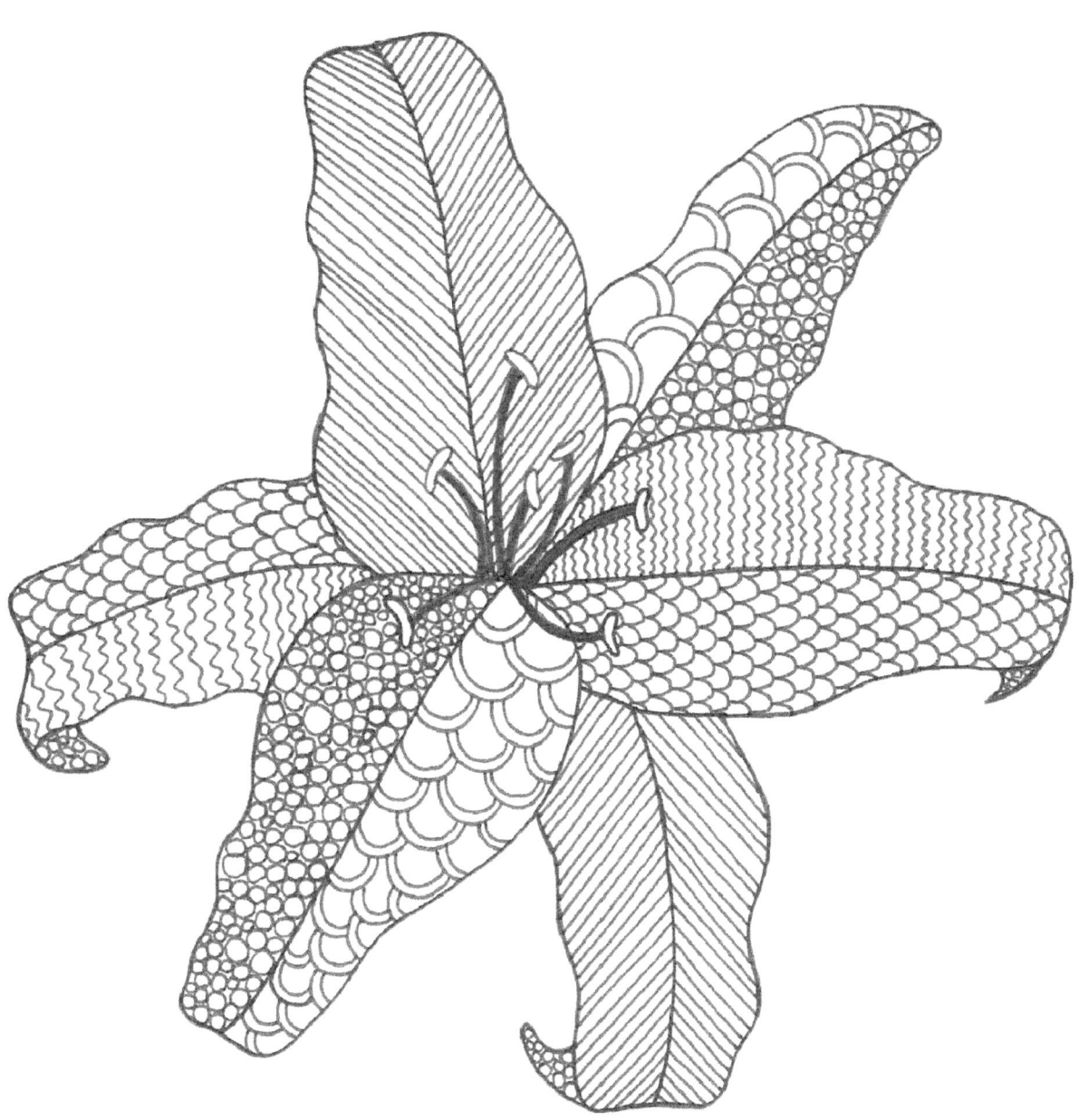

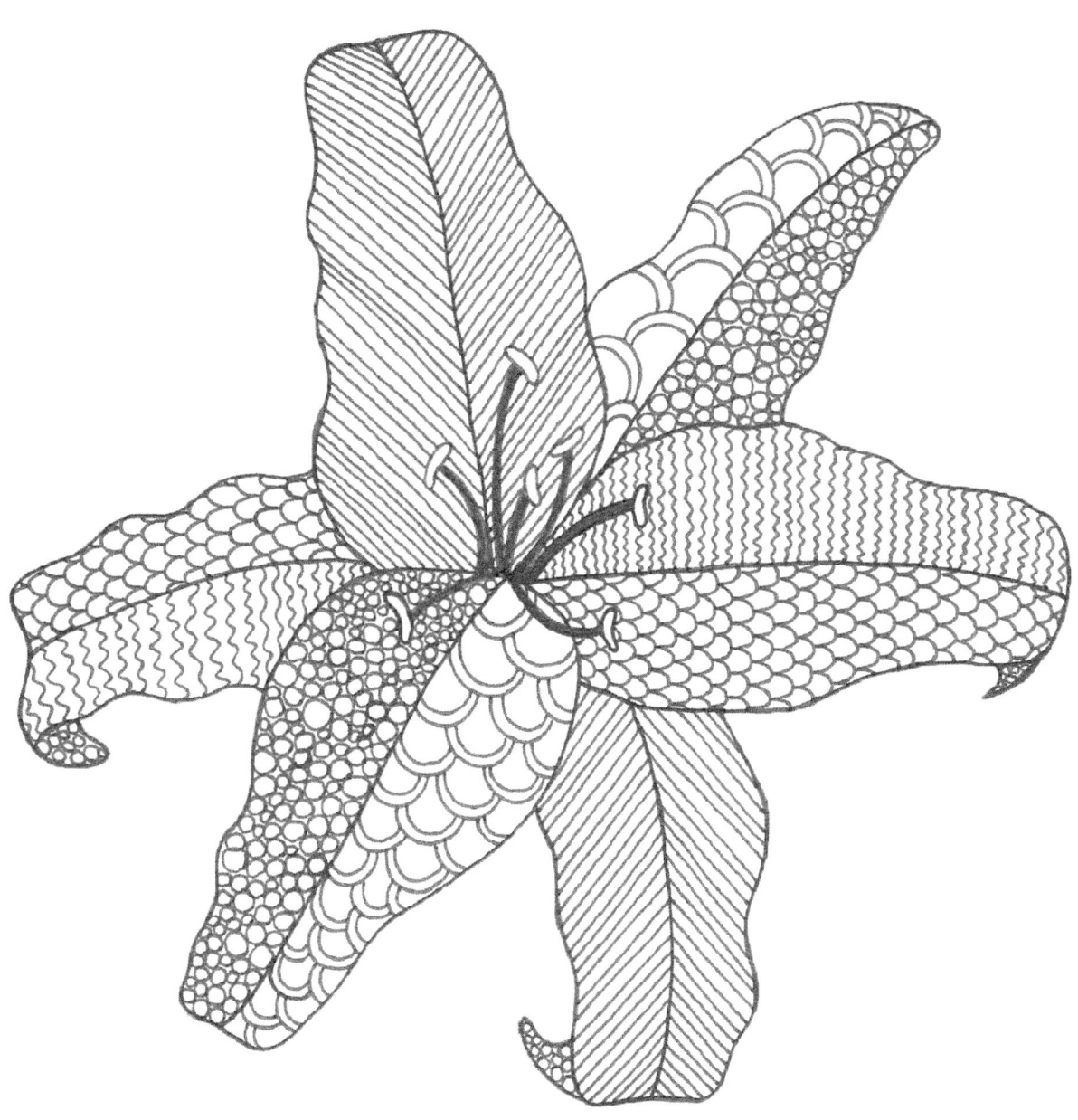

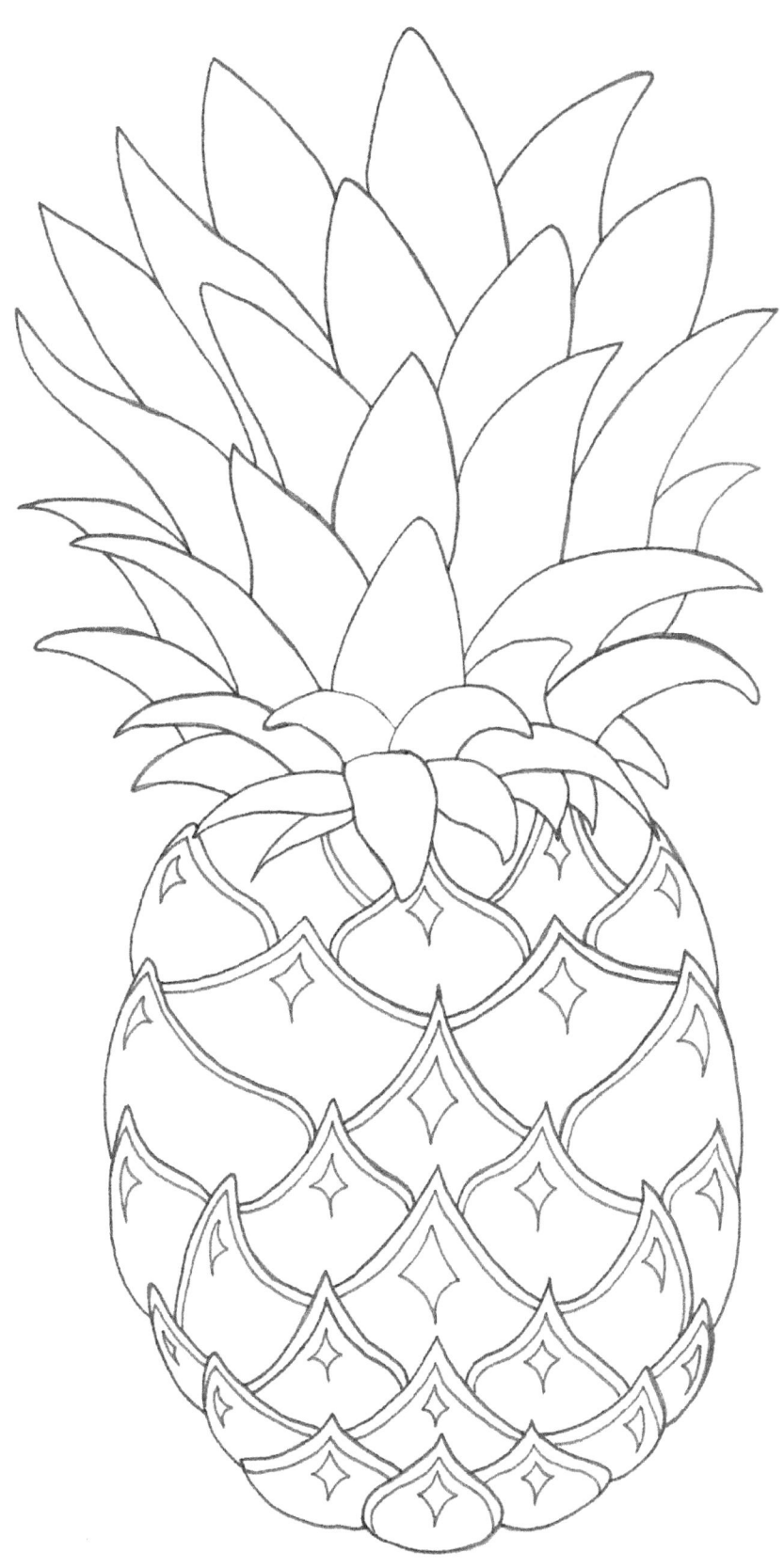

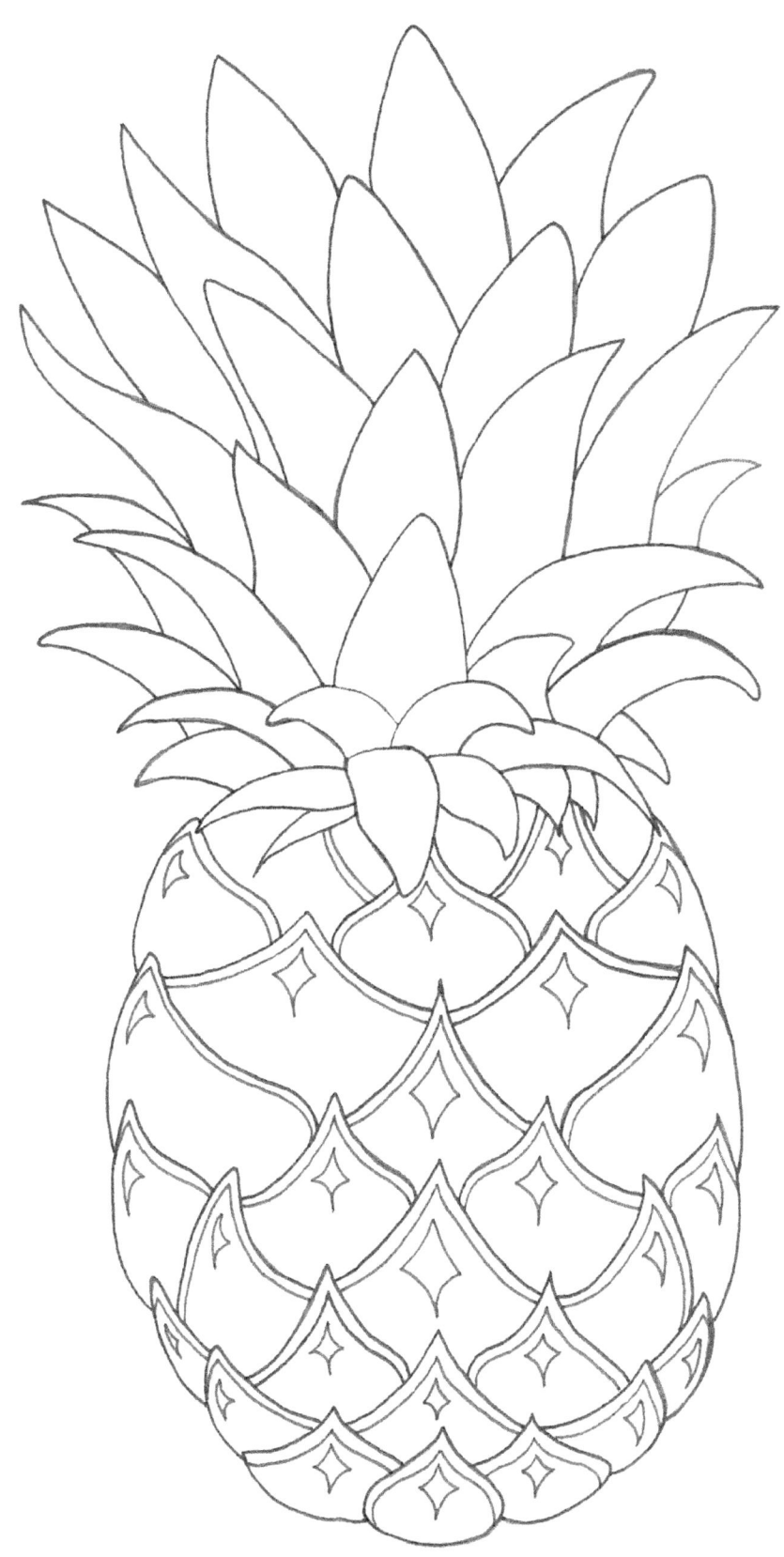

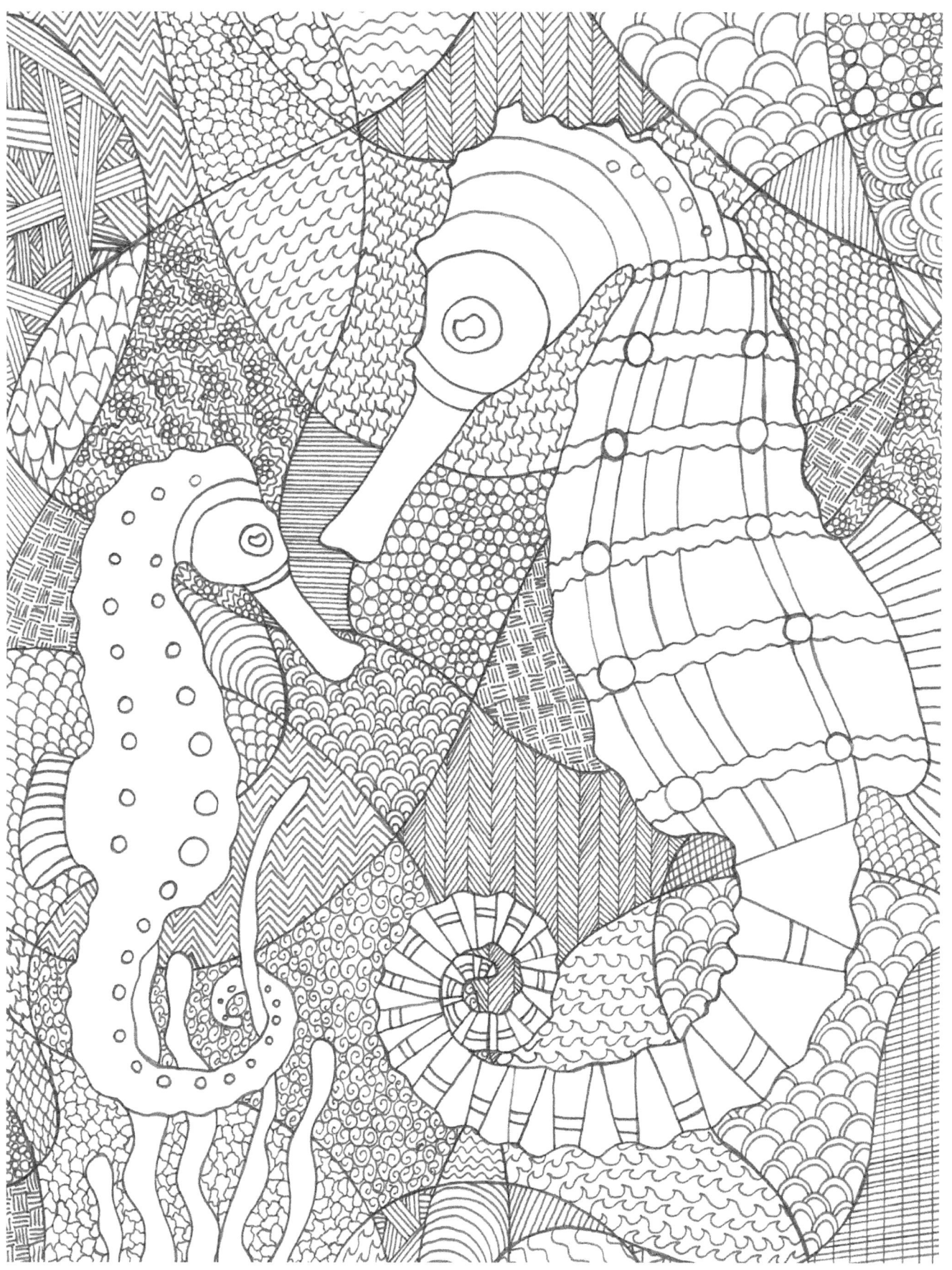

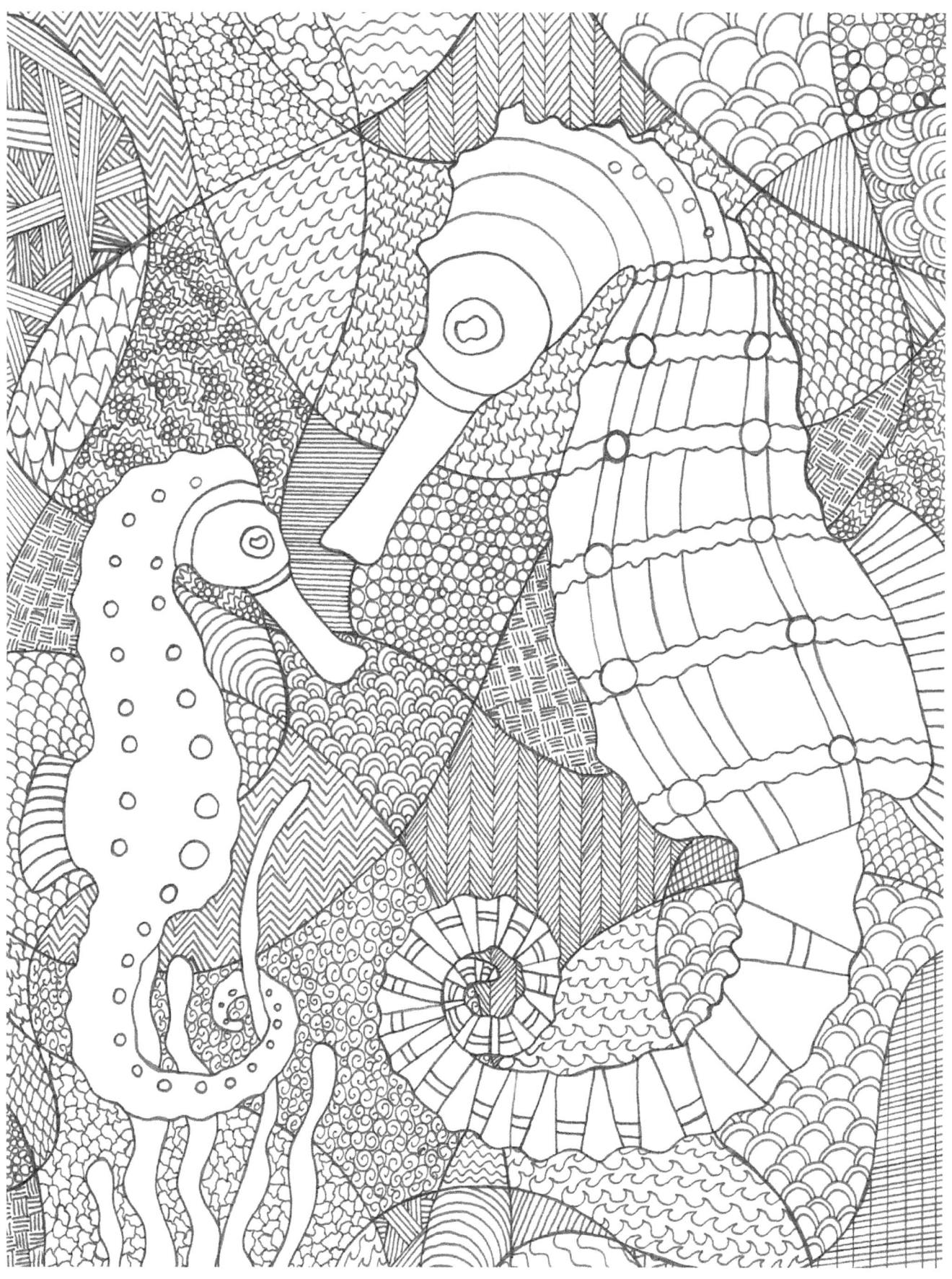

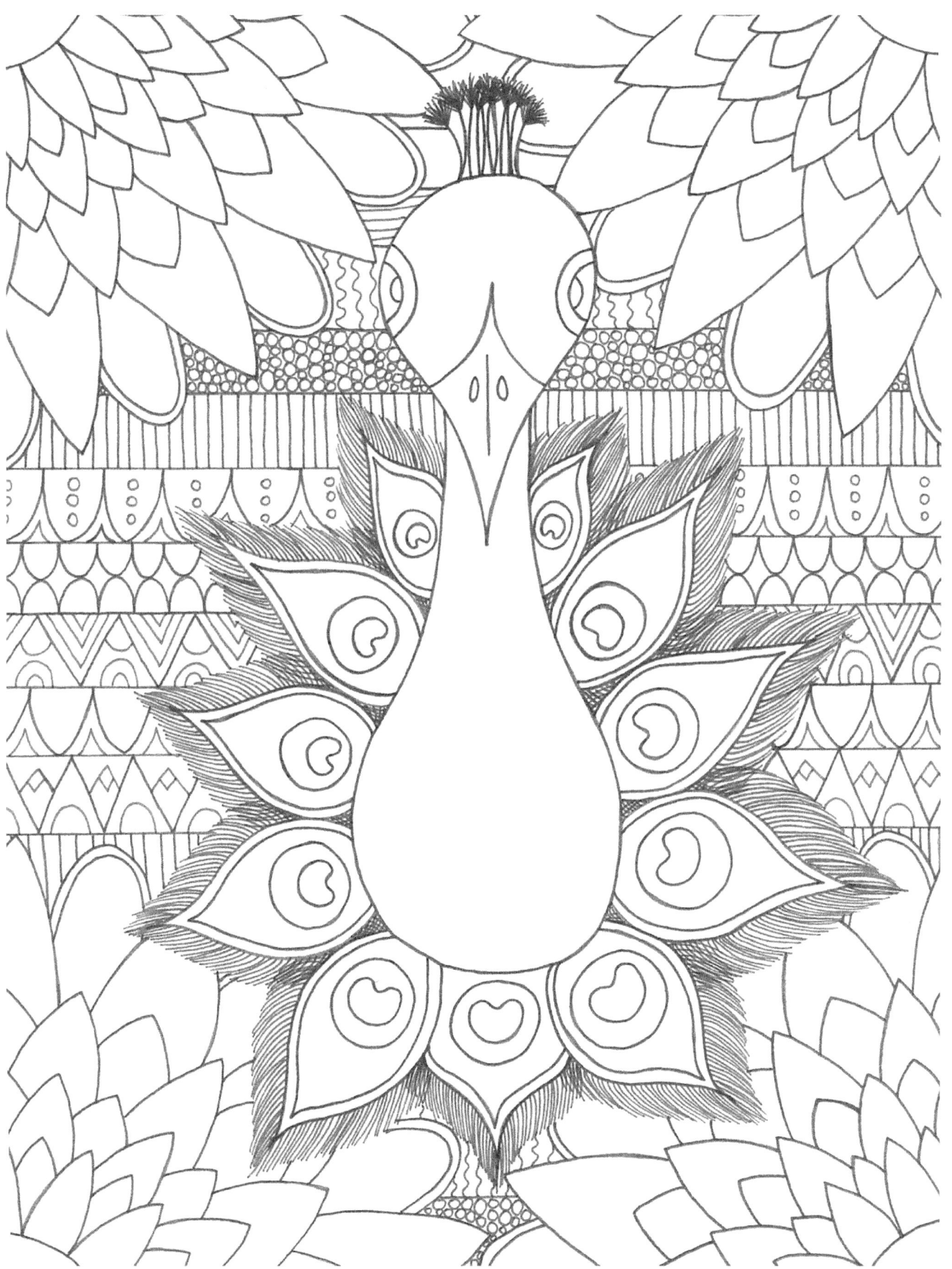

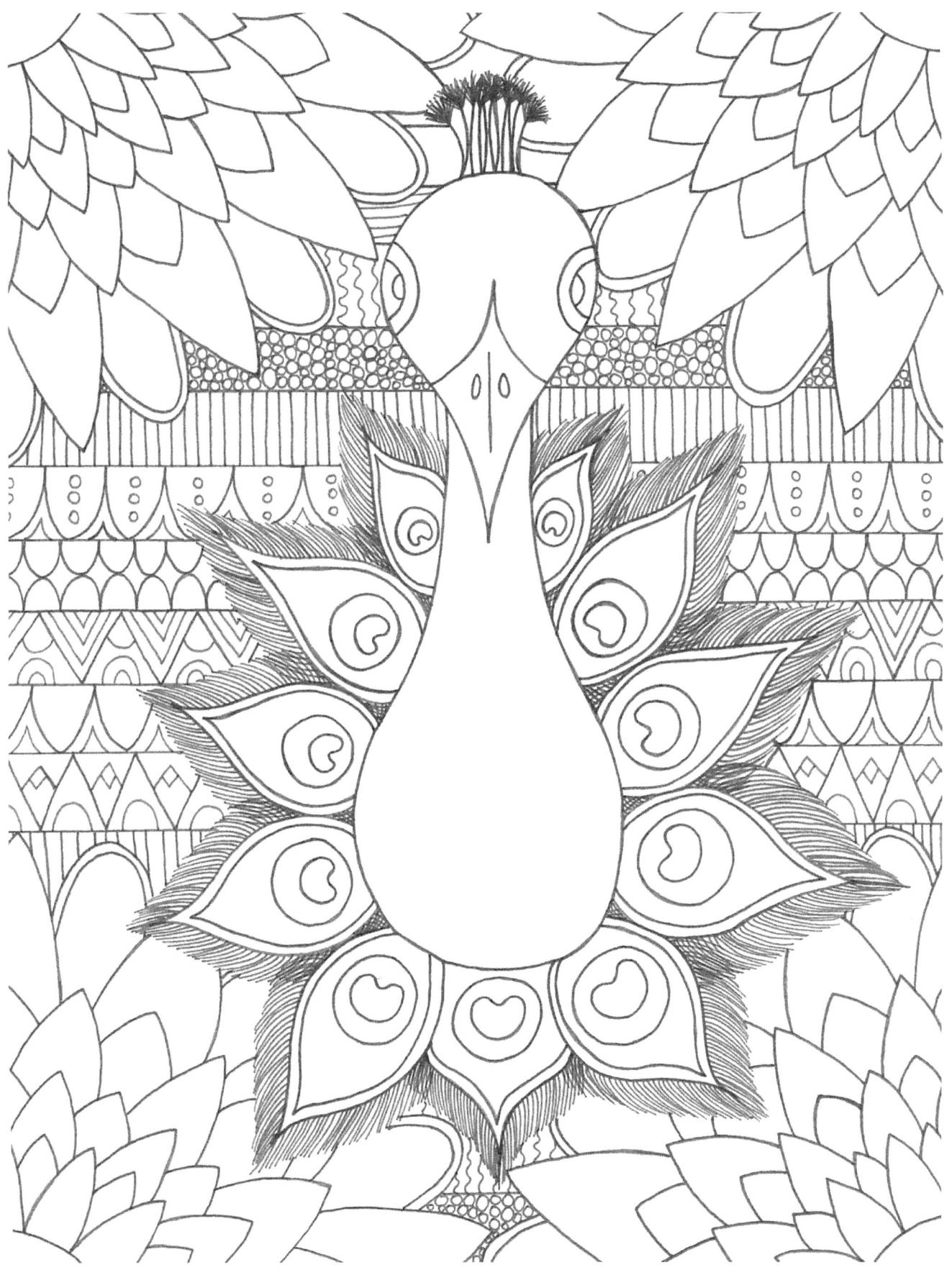

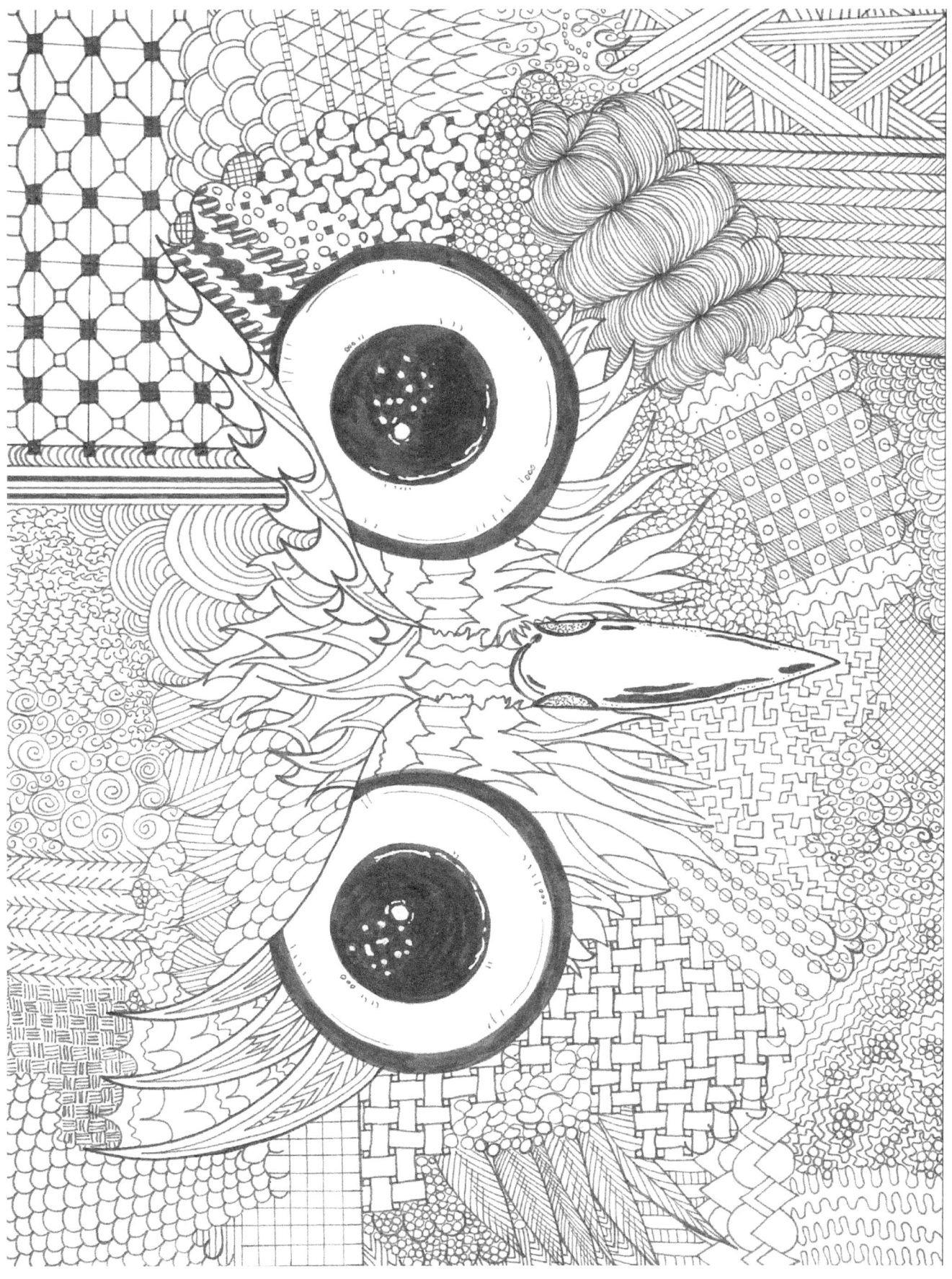

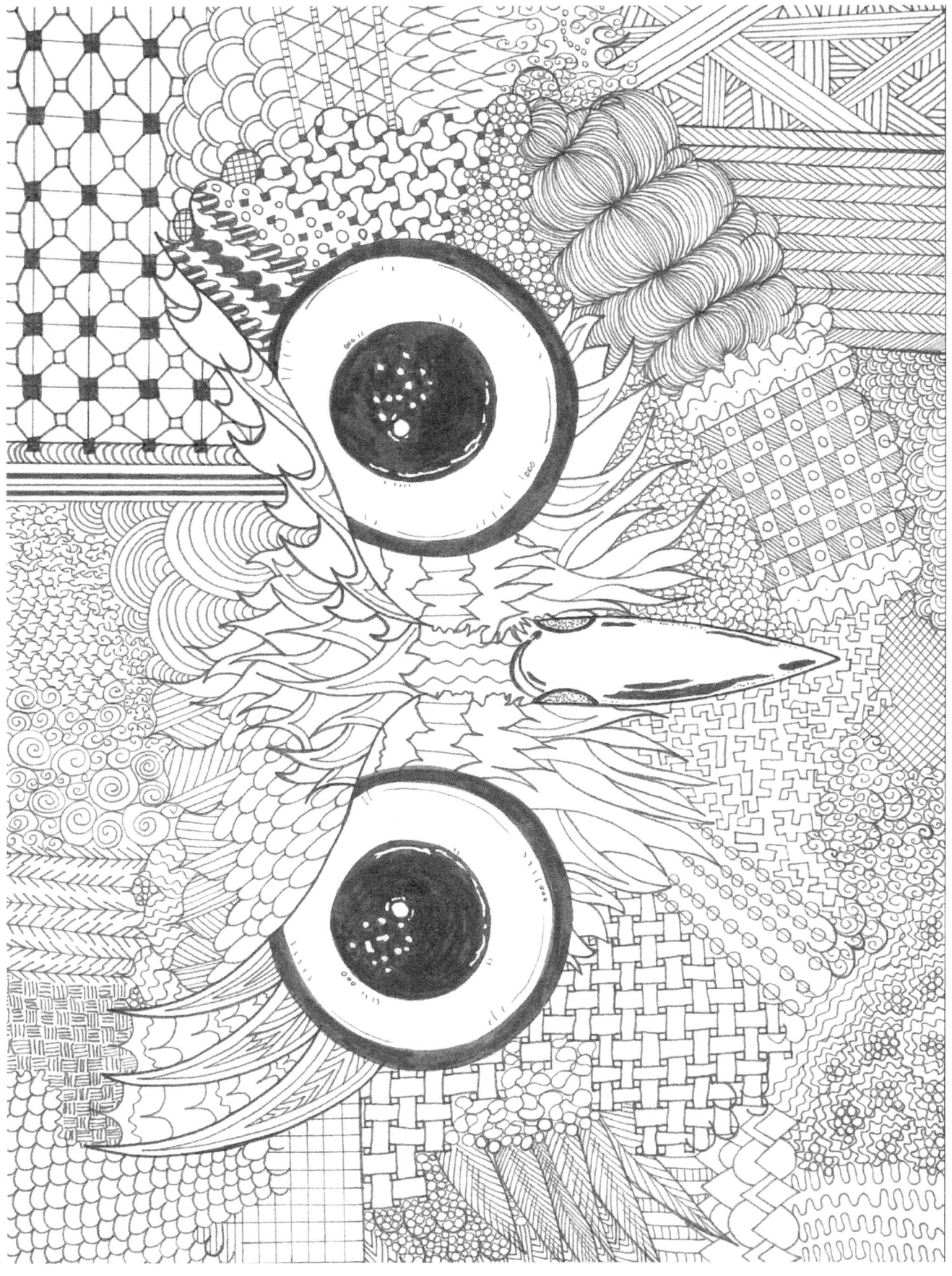

A Little Bit About Me. (The Artist)

My name is Jesse and I live in a coastal town in Central Queensland, Australia. I've always loved to paint & draw ever since I was a little boy. I came across the style of drawing commonly known as 'Tangling' a few years ago. It's fun to draw with different patterns, as it keeps it interesting. People often say they enjoy looking at my work because they can always find something new within each drawing. I've recently been working in a more symmetrical style. This is the style like the drawings in the first part of this colouring book. You can see an example of a finished piece on the cover. That piece is called 'Masked Elephant'.

I sign my work using my middle name Samuel first, then a J for Jesse. Hence 'Samuel J'. I have had requests for me to create a coloring book with my art for a while now, so here you go! I often take on commissions for pet portraits, animals and many other things. So if you'd like something created specially for you, feel free to contact me!

For now though, I hope you really enjoy creating something unique with my templates. There's definitely more to come soon!

My website is: www.samuelj.com.au
You can also follow my work on...
Facebook: Samuel J Art
Instagram: @samueljart
YouTube: Samuel J
Twitter: @SamueljArt
Email: samueljartwork@gmail.com

www.ingramcontent.com/pod-product-compliance
Lightning Source LLC
Chambersburg PA
CBHW080545190526
45169CB00007B/2644